COLOR GRAPHICS

FOCAL PRESS LTD.,
31 Fitzroy Square, London, W1P 6BH

FOCAL PRESS INC.,
10 East 40th Street, New York, NY 10016

Associated companies:
Pitman Publishing Pty Ltd., Melbourne
Pitman Publishing New Zealand Ltd., Wellington

COLOR GRAPHICS

The use of photography to produce graphic designs in color

by Pär Lundqvist

Focal Press · London

Focal Press Inc · New York

© FOCAL PRESS LIMITED 1980

Translated by Kaj Skoglund from FÄRG FOTOGRAFIK BOKEN
© 1977 Pär Lundqvist/Bokförlaget Spektra AB
Drawings and diagrams: Bo Bergman
All pictures and photographic work: Pär Lundqvist
Graphic design: Åke Hallberg
Published by agreement with the Lennart Sane Agency,
Malmö, Sweden.

BL British Library Cataloguing in Publication Data

Lundqvist, Pär
 Color graphics.
 1. Photography Artistic
 2. Print — Technique
 I. Title
 760 TR642

ISBN 0 240 51046 1

First edition 1980

Printed in Great Britain by M. & A. Thomson Litho Ltd,
East Kilbride, Scotland

Introduction

Color graphics can be produced by a number of printing processes, starting from a range of different types of original. This book concerns itself mainly with images derived from black-and-white negatives, and to a lesser extent, from color slides. Color graphics are also produced from non-camera originals (which involves placing objects (eg machine parts, flowers, herbs) on top of the film and exposing under the enlarger. These *photograms* are then used as the 'original' from which color graphics are derived.

It is necessary to previsualize the final image in order to produce colors which are aesthetically pleasing. This can only be achieved by fully understanding the intermediate steps of the process, and how each color is eventually produced. Working intuitively is likely to result in many poor images and also be very expensive on time and materials. For the beginner this previsualization is extremely difficult but as you become more familiar with all the intermediate steps, so your ability to forecast the final image improves. The tables at the back of the book should prove helpful in this respect.

I hope this book helps you to become a master of the techniques of color graphics, so that your energy can be concentrated on the more visual aspects of the image.

Contents

1. Camerawork, developing, and printing

The ideal negatives and color slides for producing color graphics are those which make darkroom work easier. But it is impossible for the beginner to know which type of negative is best. Eventually you will be able to previsualize the final image when you look at the original scene and produce a negative to suit your 'vision'. To start with, a few general guide lines are helpful.

Black-and-white negatives

The best negatives are dense and low in contrast, and should also be grainy. One approach which has produced successful results is to use a high speed film and develop it in fairly concentrated paper developer. Start by using paper developer at half its normal dilution (eg 1 + 4 instead of 1 + 9) and develop the film for about 3 minutes.

For camera exposure, it is best to 'bracket' and use a range of settings which tend towards overexposure ie normal, + 1 (one stop overexposure), + 2. This ensures your negatives are both grainy and dense.

Initial printing step

Color graphics, like many photographic manipulative processes, require several printing steps with one piece of film generating another. There may be a number of successive printings, depending on the final result required. Therefore, if it is possible, work with enlarged images, preferably to a size of 10.2 × 12.7 cm (4 × 5 in) or perhaps 6 × 6 cm (2¼ × 2¼ in). This makes later steps easier to control, especially as exact registration is likely to be required for multiple printing. After the initial enlargement, the intermediate films are usually made by contact printing. The most suitable film to use is lith film. Most lith films are available in sheet sizes, in boxes of 25 or more, and the emulsions are usually coated onto a very dimensionally stable film base. This stability is important and ensures that the image does not change size from one step to the next.

It is necessary when working from color slides to use special films (see page 39).

Coloring the images

The methods described here in outline, are aimed at producing a separate film ('color separations') for each color of the final image. These separations are then laid on top of each other in registration to give a transparency, or are sequentially printed in register onto film or color paper to give a transparency or print. It is important to try and

This series of positives are obtained by printing different negatives onto lith film:
1. From a normally developed Tri-X negative.
2. From the same original negative as 1, but the lith film has been overdeveloped (8 minutes instead of the normal 3 minutes).
3. From a negative developed in paper developer (see page 8).
4. This effect is achieved by printing the negative onto lith film which has a texture screen in contact with it (see page 46).

1

2

3

4

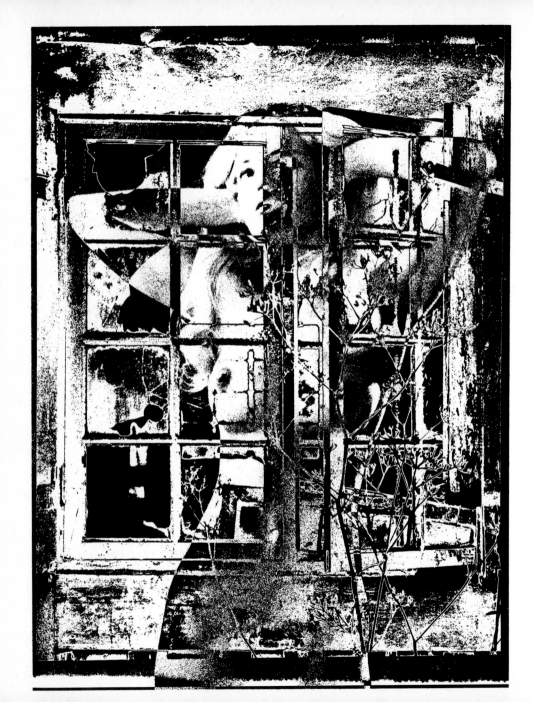

This picture is produced by combining two different lith images. It is possible to dye several of these images and combine them for color printing or projection (see pages 29–30 and page 41).

previsualize the final colors and their arrangement.

The separation films can be colored by three main methods: dyeing, printing on Color Key film (or similar material), and by conventional color printing. The dyeing method is time consuming but the least expensive: 3M's Color Key system (see page 85) requires special equipment; and color printing obviously needs a color enlarger and associated equipment.

Dyeing method

This method is similar in principle to the Kodak Dye Transfer System for producing prints and large transparencies. Each color separation film is printed onto a special thick emulsion and then developed as normal. After development each film is put into a stop bath, quickly rinsed and then into an etching bath – which dissolves away the silver and gelatin in the image areas. Finally the film is fixed and washed. This results in a 'negative' relief image in gelatin from each color separation film. These relief images can now absorb any dye color, and be transferred sequentially in register onto a single receive film or paper. As both the development and etching steps are 'negative working' it is necessary to start with a positive color separation to obtain a positive final image.

Color printing method

This method is not described fully in this book as it is available in a number of other publications. For producing color graphics using the color printing technique the procedure is:

1. From a black-and-white negative produce three (or more) separations by tone elimination, blocking-out techniques, etc. If you start from a color transparency then this should be separated by use of color filters into various black-and-white lith images – this color separation does not have to be 'literal' (ie red, green, and blue filters giving cyan, magenta, and yellow dyed images).

2. Print sequentially in register the three or more separations, using color filters, onto the color paper or film. Any choice of color can be made when printing to give a range of possible color images.

Silkscreen and lithographic prints

For both silkscreen and lithographic processes, the separation positives can be printed directly onto the silkscreen tissues or the lithographic plates.

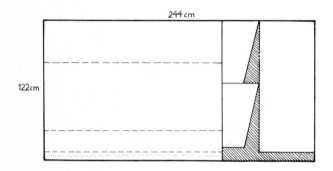

This contact printing frame is simple to make using 5mm (¼ in) plate glass and 15mm (1½ in) plywood or laminated chipboard. Tape or leather which is stuck with epoxy glue can be used for the hinges. The wooden baseboard should be covered with thin black felt to minimize light reflection.

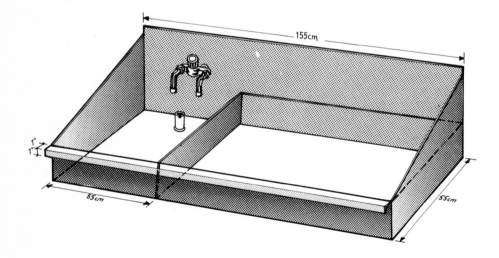

The 'wet-box' can be made of 3mm (⅛ in) PVC or similar plastic. The simplest method is to have the front-bottom-back piece pre-formed by a specialist store or manufacture and to weld the sides on separately. Connect the plumbing directly to the box.

2. Equipment for color graphics

A *light-box* is needed when making color graphics, it being used for both aligning and examining original and intermediate films. These can be bought or made quite easily and should use specially color-corrected fluorescent tubes as their light source.

For *contact printing* a good frame is required which should also have some kind of registration system for aligning films. These can be made (see opposite), or bought either new or used. This contact printing frame should be kept scrupulously clean as any marks or dust spots are multiplied as the number of printing steps increases. A convenient light source for contact printing is the enlarger, but do ensure that the printing light is defocused, otherwise dust spots within the enlarger are projected onto the printing frame.

Darkroom equipment

It is best to use as large a film size as is possible when making color graphics as this simplifies alignment, dust and other problems. It is always possible to buy used 4 × 5 in enlargers and this is a better purchase than a new smaller format enlarger. Enlargers handling up to 6 × 6 cm (2¼ × 2¼ in) negatives are a good second choice but 35mm enlargers are very tedious for color graphic work – alignment of this small film size being a major problem.

Most films used for color graphics are sensitive to both blue and green light (ie orthochromatic materials) and a *red safelight* is needed

Developing dishes should be just bigger than the film size you are using, this helps reduce expense and means fresh developer can be used more frequently. It is well worth having a separate set of dishes for dyeing work.

Although not essential, a *developing box* (as shown opposite) is a useful and clean method of working. These can be bought readymade or can be built by yourself or a craftsman to suit your exact spatial needs. It is convenient to support the developing box upon a cupboard which can be used to store chemicals.

3. General working technique

Contact printing

As there are likely to be several stages requiring contact printing, it is important that your printing frame is well constructed. Any lack of contact between films produces unsharp images, and when several stages are involved any unsharpness on one film becomes even less sharp on the next. Do not use thin cheap glass but buy a thick good quality plate glass. Keep all surfaces clean. Exposure of lith films is critical, any overexposure causes the image to spread while underexposure produces thinner lines. Variations between exposures for the different color separations therefore give slightly different line widths, causing color fringes.
Directional light produces the sharpest contact printing, the enlarger being an ideal light source. Diffuse light sources should be avoided.

Films must be emulsion to emulsion in the contact printing frame, otherwise the resultant image is unsharp. The emulsion side of a film is facing you when the code notch is in the top right corner and the longest side is vertical. When there is no code notch, as with roll films, then the emulsion side of a processed image can be recognized by its slight relief image.

Film drying

When drying film in a drying cabinet be careful not to wash with too hot water, as the emulsion may melt. Hot water makes the emulsion swell more than usual and therefore retain more water. This extra retained water increases the heating effect of the dryer.
The temperature of the wash water should be around 20C (68F) and the film should be wiped with a clean wet squeeze blade to avoid drying marks on the film. A little wetting agent in the final rinse also promotes even drying.

As color graphics involves making many
intermediate films, it is essential that films are
dried rapidly. Use either a squeegee blade (see
above) or a wiper blade.

4. The original camera exposure

For the best results it is essential to take photographs specifically for color graphics. Although it is possible to use 'old' negatives and slides, these are seldom completely satisfactory. In fact some of the examples in this book required several exposures of the original scene from the same position – these separate exposures had to be planned with the final image in mind. The table on page 104 should help you plan your camerawork.

Tonal control of negatives

As mentioned in the first chapter, it is best to produce a high-density low-contrast negative of the original scene; this being ideal for making the separations. But another method of producing tone separations is to photograph the original scene more than once, each exposure giving a negative of different density. For example on page 25, the positives 1, 2, and 3 (4 was achieved by solarization) were obtained from three different negatives, 1 being underexposed (no shadow detail), 2 being normal camera exposure, 3 overexposed (no highlight detail). These three original negatives have therefore separated the scene into various tones. It is best to shoot more than three exposures, each at one stop intervals, and select the best negatives (slides) later in the darkroom.

Exposure time variations

By taking several equivalent exposures of the original scene but using different shutter speeds (eg. 1/60 sec $f4$, 1/15 sec $f8$, 1/4 sec $f16$) some interesting separation negatives can be produced. Obviously, this method works best when the subject is moving, the various exposure times producing different blur patterns. This technique was used for the picture on pages 66–67. A whole range of original camera exposures was taken, the best three being selected when the separations were made. Each separation was solarized.

Double and multiple exposures on the same piece of film is also a useful technique. The picture on page 73 was made this way.

A firm tripod is absolutely essential when making multiple exposures.

Combining different subjects

Where several negatives (slides) are purposely made to be combined on printing (by sandwiching or sequential printing) it is important to visualize how

the different images fall upon one another. Usually the final combined image consists of a main subject and a background subject as two distinct images. The background subject should consist of large even (preferably dark) surfaces and not contain any fussy detail. Sometimes the background image can be photographed out-of-focus to aid delineation from the main subject.

Using 'old' negatives

Although generally not an advisable technique, these negatives (slides) can produce excellent results if you copy small portions of them – they then have the grainy appearance which is necessary for good color graphics. A bellows unit and slide copying attachment are ideal for this work.

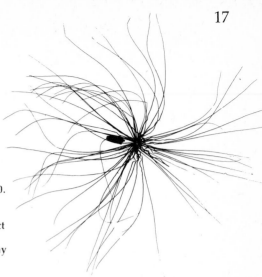

This picture of a seed has been used as the starting image for the color graphic on page 70.

Below: the black-and-white part of the color image on the next two pages. The grain effect has been achieved by using a texture screen made from a half-tone film having a light gray tone.

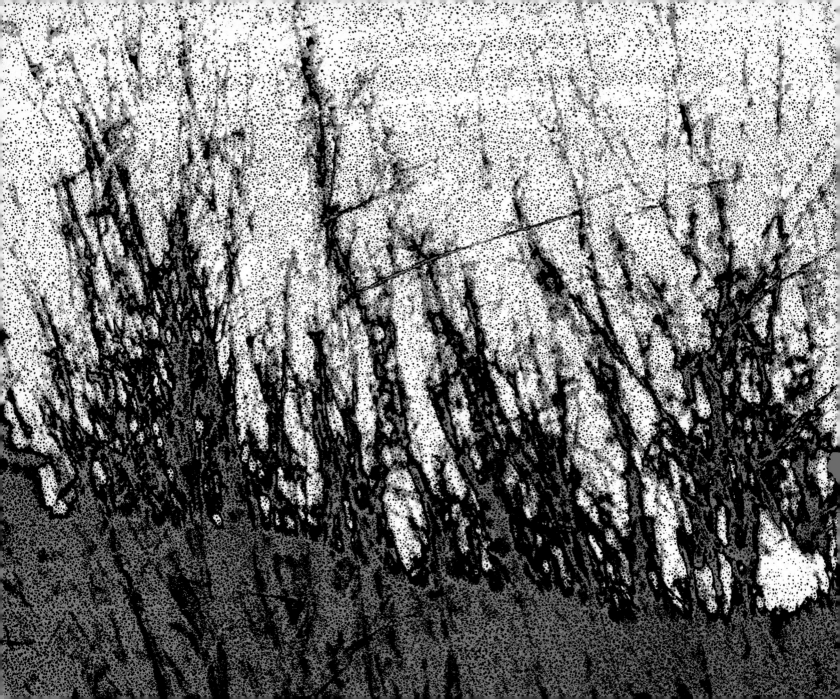

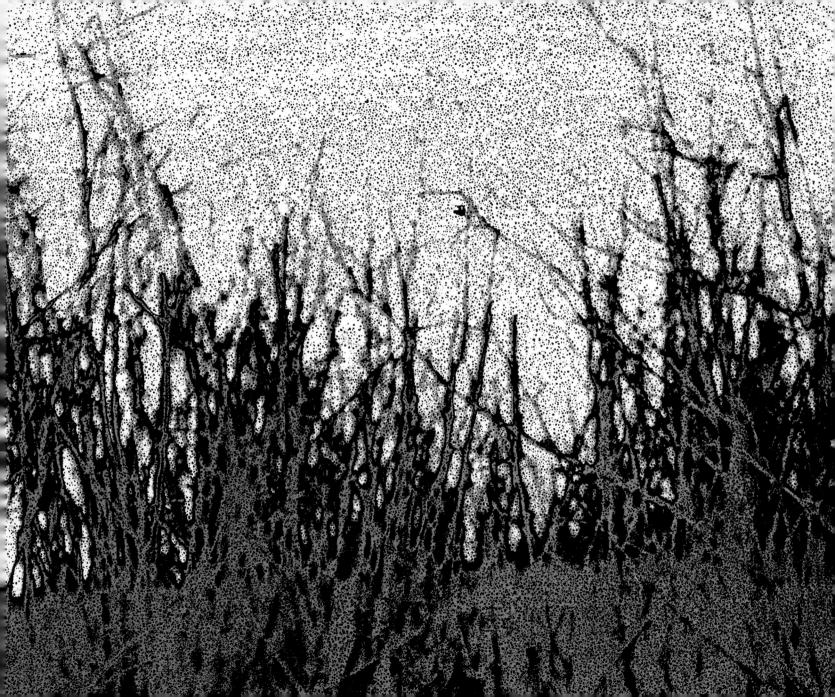

Negatives directly from plants

Many of the photographs in this book have been derived directly from images of plants. The original negative (slide) is made either by placing the plant directly onto the film (see photograms below), by sandwiching the plant between the glasses of the enlarger negative carrier and projecting onto the film, or by photographing the plant in the normal way. The first two methods require no camera and are suitable for smaller objects.

Many objects found in nature, such as dead leaves (see pages 51, 71), are very delicate and must be handled carefully. This is particularly true when placing them between the glasses of the negative carrier. It is easier to work with damp leaves, often found in springtime, rather than the dry brittle leaves of autumn.

Try to use simple shapes having clean surfaces and strong lines.

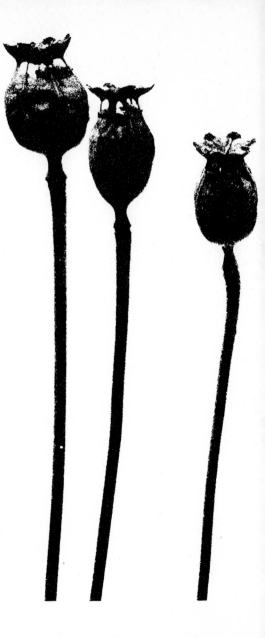

Photograms

This technique involves placing objects, such as cog wheels, on the film and exposing by the light of the enlarger. It is important to *focus* the enlarger light onto the film and also to use a small lens aperture (about *f*11), otherwise the images are not sharp.

All objects must be very clear, as any dust particles are clearly visible on the final image. Photograms are easy to make and the technique should be used more often. The picture on page 23 is made from photograms.

Other methods

There are a number of other non-camera techniques which can be used for color graphics, including various forms of OP-art and reprographic systems. You should experiment with anything which might produce a novel image.

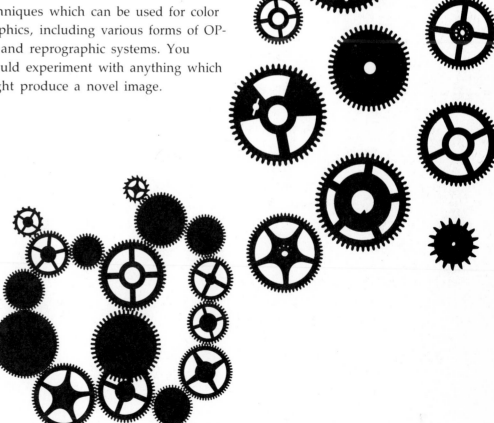

Below: two separations which have been used to produce the picture opposite. Right: this film has been used to produce both the colored and the black part of the picture. Note that the black image is totally reversed when compared to the colored image, and that both films shown below have been used when producing the colored image. Left: this image incorporates a line-solarization of the film on right.

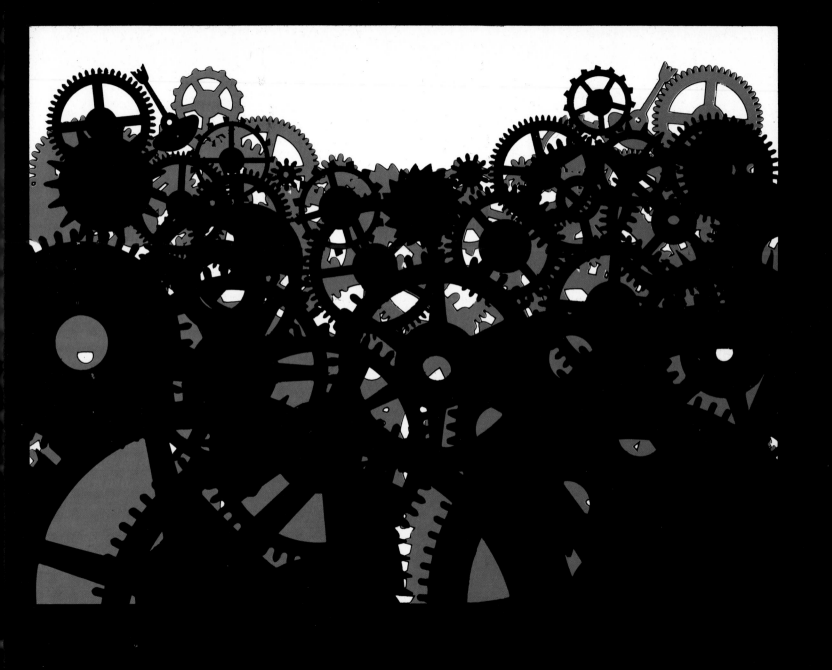

5. How to make the films for the different colors

There are a number of techniques (eg lith prints, solarization) which separate the original black-and-white image into component parts of the final image. These component parts (separations) are then combined to produce the final colors – this being achieved by laying several dyed images on top of one another in register to give a print or transparency, or by being sequentially printed, using various colored filters, onto color paper or film. The number of possibilities from one original image are infinite. On pages 39 and 56 are guide lines on how to achieve the separation of the original image.

The techniques described below can either be used separately or in combination. For example the picture on page 83 is a combination of solarization and lith techniques.

Lith method

This is the most common technique and uses lith(ographic) film; a film having extremely high contrast. The method works best when the original is grainy, the lith film separating the negative into either black or white (no midtones). The grain structure, like a half-tone dot pattern in a newspaper, carries the picture information. It is best to use fast films for color graphics.

Tone separation method

This technique produces a number of films (which later give different colors) of different density from the original negative. The method works best with originals having a long range of tones in a well-exposed dense negative.

The illustration opposite shows various tone-separation positions from the one original scene. For successful color graphics using this method, at least three separations are needed (see page 81).

Opposite: three tone separations, each one from a different camera exposure: 1, from an underexposed negative (shows only highlight detail). 2, from a 'normal' negative. 3, from an overexposed negative (shows only shadow detail). The fourth picture is a solarized image produced from the other three (1, 2, 3) The color print on page 81 is produced from those tone separations.

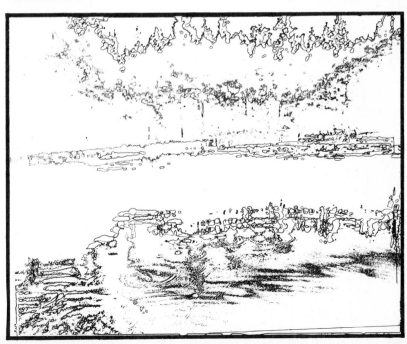

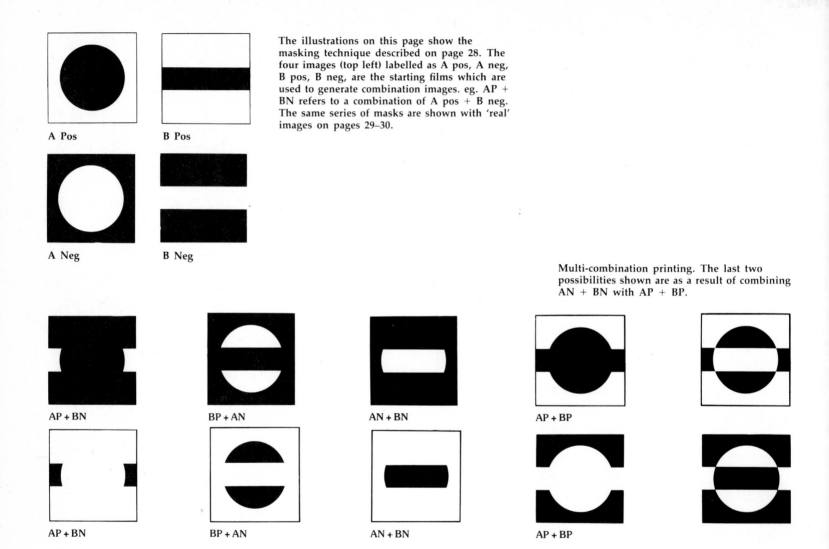

A Pos

B Pos

A Neg

B Neg

The illustrations on this page show the masking technique described on page 28. The four images (top left) labelled as A pos, A neg, B pos, B neg, are the starting films which are used to generate combination images. eg. AP + BN refers to a combination of A pos + B neg. The same series of masks are shown with 'real' images on pages 29–30.

Multi-combination printing. The last two possibilities shown are as a result of combining AN + BN with AP + BP.

AP + BN

BP + AN

AN + BN

AP + BP

AP + BN

BP + AN

AN + BN

AP + BP

Exposure and processing of lith films

You should produce a range of separation films from your original negative – from short printing times, which produce only shadow detail on the separation positive, through normal to long times, the latter producing only highlight details. A range of separation films generated in this way gives you a choice of films to be dyed or to be used for color printing.

Develop your films in lith developer for at least 1½ minutes at 20C. Films receiving short printing times and which therefore give only shadow detail, should be developed for longer times, thus ensuring fine shadow detail without recording any mid-tones or highlights. Although the colors in the final picture are a subjective choice, it is usual to reproduce the shadows in a dark color and the highlights in a light color.

It is always possible to combine several films if the density of one is not quite sufficient to give distinct separation of tones.

The use of masks when printing

In photography the technique of masking means to cover one part of an image so that another one can be printed or inserted in its place. The two main masking techniques are *photographic masks*, which are made to exactly 'hide' an area of an image, and *non-photographic masks*, which can be as simple as cut-out pieces of card or printing on the film with photo-opaque material.

The photographic mask is made from the subject film which you wish to insert into the main image, and is visually successful when the inserted image fits into an uncluttered area of the main image. In color graphics each mask 'holds back' an area of the final image so that only the selected color is produced in this masked area. Several masks are required for each color graphic image.

The mask(s) is registered in contact with the film which contains the subject area being printed. This masking technique is illustrated on pages 29–30, where ten possible final images are obtained from only two original images.

The masking technique can be used for the combination of two or more subjects (masking one subject into another) or it can be mixed with other techniques such as tone separation.

Combined masking

In this method, two or more subjects are combined in the final image, as shown for example on page 26. The main rule to observe is to always place smaller detail into larger areas. This is achieved by taping a positive of the small detail to the main image negative, which should be relatively transparent in the area where the detail is inserted. If necessary you can hand retouch either the mask or the main film – this is usually done on a positive and from this a new negative is produced.

A series of masks produced according to the scheme illustrated on page 26.

A Pos

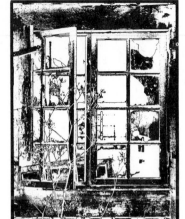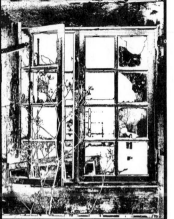

B Poś

AP + BP

AP + BN

A Neg

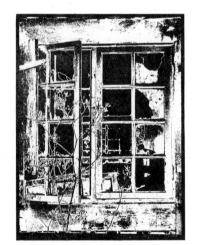

B Neg

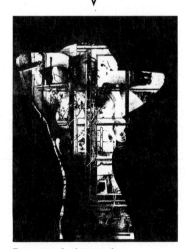

Reverse of picture above

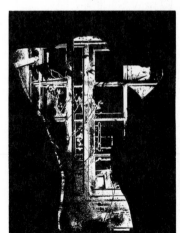

Reverse of picture above

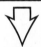

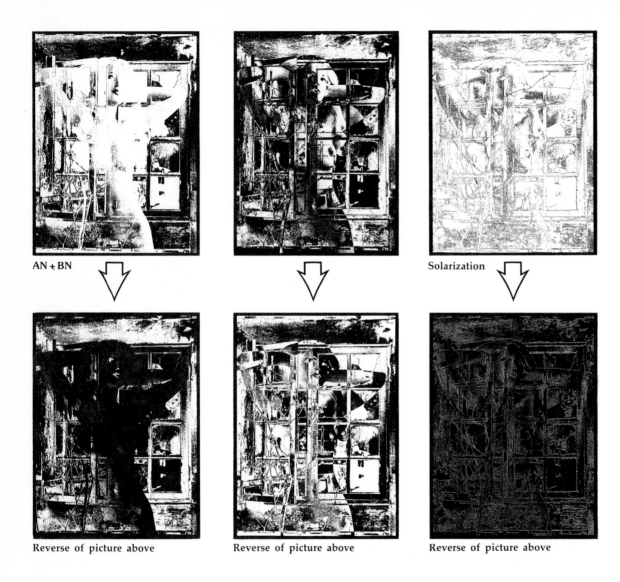

AN + BN

Solarization

Reverse of picture above

Reverse of picture above

Reverse of picture above

The picture in the middle of the top row is obtained from a combination of AP + BP and AN + BN (see also page 26).

Using masks to improve detail

Masks can be used to improve apparent fine detail when tone separations are made. A low density positive is registered with a light negative to give a crispening of fine detail.

Direct masking

This technique involved making four or more positives of different density from the original negative and from each other of these positives making a complementary negative. It is essential to mark all films so that they are easily identified. The first printing is made using the lightest positive combined with the lightest negative. After this, any combination of negative and positive can be tried. There are many possible combinations.

The 'first generation' films made by combining negatives and positives can then be used to make 'second generation' films, and so on. In fact second or third generations can be combined with first generations. There are no rules – what looks pleasing must be correct.
A clear marking system helps identify each film; numbers written on the film rebate using a fine tipped pen and photo-opaque are ideal.

On the following pages are a series of masks derived from tone separation films. On page 32 (1 – 6) are positives and negatives derived from the same original negative. Pictures 7, 8, 10 and 11 are derived from films 1 – 6.
Pictures 9, 12, 13 and 14 are more complex derivatives, with some of them having been retouched with photo-opaque. The color print on p. 75 is made from four of these films.

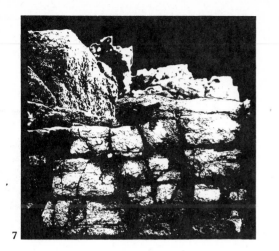

7

8

9

'10

11

12

▶

13

14

Technique of solarization

Some of the pictures in this book have been made entirely by using the solarization method (pages 73, 74 and 80); many other pictures have been produced from one or two intermediate solarized films. The black outline around colored areas is typical of a solarized image.

Solarization is the technique of exposing the film or paper half-way through development. It is a difficult process to master at first and you should experiment with strips of film before wasting expensive materials. It is also important to make notes of your experiments as you go, so that the best results can be repeated. As a starting guide you can try exposing the film after one minute development for about two

seconds to a 25 watt lamp in a reflector held about one meter above the dish. Do be extremely careful to ensure that all your equipment is electrically safe. A small electronic flash-gun (preferably adjustable) can also be used for the exposure. After the 'fogging' exposure do not agitate the developer for the remaining 1–2 minutes of development. The film now appears almost black but should show a solarized image when held up to a bright light source. The solarized image can be 'extracted' from this dense film by copying onto another film.

For most solarization procedures line film works very well, but for more dramatic results Agfacontour film is well worth trying. It is printed through a yellow filter and is processed with a specially formulated developer (see page 56).

Line solarization

Apart from using Agfacontour films, line solarization can be obtained using lith films. As these films are later used to produce the separate colors of the final image, it is essential that they are in perfect registration. This means that each film must be derived from other films by contact printing or use of an enlarger with registration guides.

The lith film can be processed in lith or paper developer, but it is essential to use fresh developer and to keep the temperature above 20C. Therefore the lith developer, which deteriorates quite rapidly, should be changed every hour so it is best to use only small quantities in the smallest dishes possible.

It is important to balance the solarized image with the printed image so that there is equal density on both sides of lines. For example, if you start with a negative image and the positive image from this on the solarized film is lighter than the rest, then your printing exposure is too short. If the printed image is darker, then either the printing exposure is too great or the fogging exposure during development is insufficient. Sometimes a tone can become lighter as a result of more exposure, as with long printing exposure followed by an exposure during development, this is true solarization and is due to an excessive amount of overexposure.

The masking techniques already described, can be combined with solarized images to produce the various colors of the final image. The masks are made in the same way as for direct

masking. As with most color graphic images, the number of possible combinations is infinite, so be prepared to experiment as much as possible.

The color print shown opposite was made by using both solarization and tone separation techniques. The camera was intentionally moved during the initial exposure to give the blurred image.

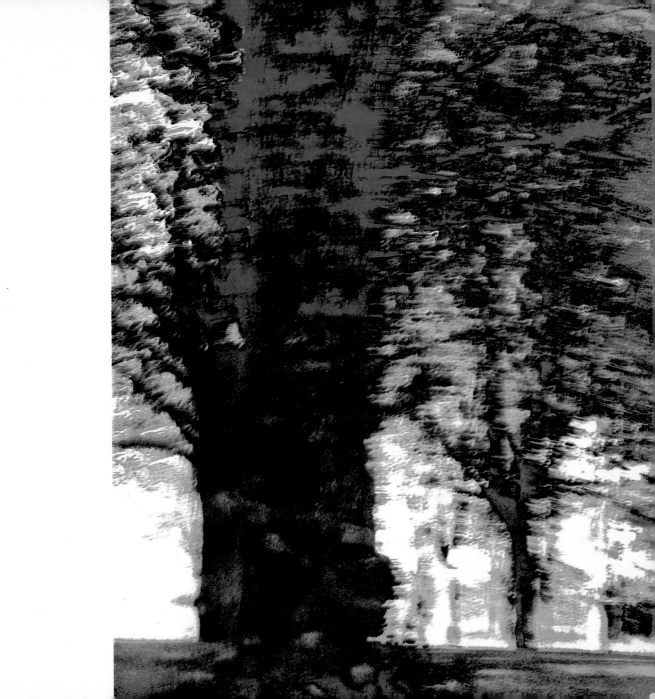

The strongest effect of using solarization is the resultant mixing of positive and negative images. It becomes very difficult to visually separate these and it is nonsense to talk any more of having a positive or negative. By using masks it is possible to favor one or several colors for the solarized part and to select other colors for the conventional image. Initially the whole process is very much hit-and-miss but with practice you are able to predict, to a certain extent, the final result. Even after many years of experience it is still exciting to discover an unexpected but beautiful image. The creativity in the process is the recognition of what works best and then how to improve it even more.

6. Producing color graphics from color transparencies

It is extremely simple to produce color graphics from color slides but unfortunately it is difficult to reproduce anything but the original colors in the final image. It is possible, however, to interchange these colors to produce a false color image, not unlike images on Infra-red color film.

The process from slide to color graphic consists of three main steps: 1, separation of the slide into its component colors to give separation films; 2, printing of separation films; 3, transferring to color material.

Obtaining color separation films

The negatives (usually three) obtained from the original (positive) slide should be rather dense and of fairly low contrast. This is best achieved by overexposure and processing the *panchromatic* lith film in paper developer. They should also have a very pronounced grain structure so that when they are printed onto lith film, all the fine detail and mid-tones are not lost (the details are retained by the grain structure acting like a half-tone screen). Coarse grained negatives are produced when fast camera films (eg Ektachrome 400) are used.

The technique of separating the original slide into its component colors is very similar to that used by the graphic arts industry to produce color pictures in print, the main differences being that a half-tone screen is not necessary for color graphics.

Separation

The colors of the original transparency are separated by copying the slide through three filters: red, green, and blue. You need to overexpose a panchromatic lith film and process it in a paper developer to obtain three dense but low-contrast negatives. The red-separated image will eventually be printed as cyan, the green-separated image as magenta, and the blue-separated image as yellow.

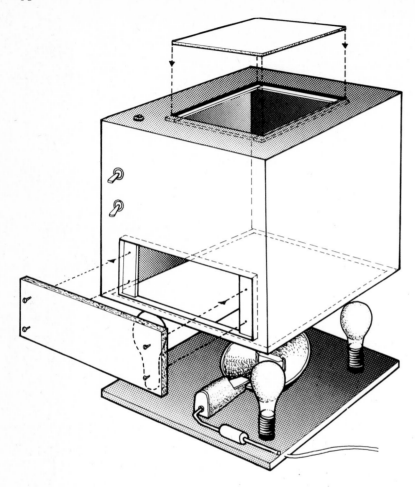

As mentioned in the text, a 'flash-box' can be used for producing color separations of an original transparency. This can be constructed out of chipboard or 4mm plywood for the base, front and lid. The opening on top for the glass should be bordered with 5 × 10 mm pine, these strips being glued onto the inside of the lid to produce a frame for the glass to slip into. A simple mains-powdered electronic flash is then mounted inside the box with tungsten bulbs alongside to be used for viewing and focusing. The tungsten lamps should be turned off during the actual exposure. All switches, synchronizer lead, flash charge indicator should be mounted on the outside of the box. It is best to use two pieces of glass and surround the slide with black paper to mask unwanted light.

This picture is derived from two different
subjects which have been combined using a
masking technique (see pages 29–30).

As well as the three color separations, you should produce a *black* separation negative; ie copy the original slide without a filter. This black separation should be two stops darker than the other separations and is sandwiched with an *unsharp mask* before printing onto lith film. This unsharp positive mask is made by contact printing from the negative through a diffusing sheet(s) onto lith film. It should be of low density and its purpose is to reduce contrast in the shadows when bound up with the negative.

The color filters used for separation are Wratten numbers 25 (red), 58 (green), and 47 (blue). Their filter factors vary according to the light source you are using, so it is best to run a couple of test films through the camera and include a gray scale (see page 40). The most consistent light source to use is an electronic flash which can be built into a homemade *flashbox* (see illustration on page 64).

It is a good idea to include a gray scale with every separation you make and to include some identification mark on the separation film to show which filter was used. The gray scale is used to check the density of each separation negative and any intermediate films. The three gray scales (excluding the *black* separation) of the color separations should match each other as closely as possible to ensure accurate color in the final image.

Any camera which is capable of close-up work is suitable for copying the original transparency, but the best results are obtained if you use bellow units, extension tubes, or macro lenses, and not close-up lenses.

Separation negative using a blue filter

Separation negative using a red filter

Separation negative using a green filter

Separation negative using no filter (black separation).

Printing of the separation negatives

The separation negatives are printed onto lith film, with each separation (except the black separation) being given the same exposure and being developed at the same time. The density of the positive from the black separation negative is controlled to suit each particular picture. The lith positives should be as 'soft' as possible. This is best achieved by overexposing and keeping development time to a minimum. Even softer results can be obtained from lith film by underexposure and long development times (up to 8 minutes). This latter technique produces very dense shadows while the highlights are delicate and have a very distinct grain structure. The separation positives produced from the above method are later contact printed again to give lith negatives and these are then used to give the final color graphic image.

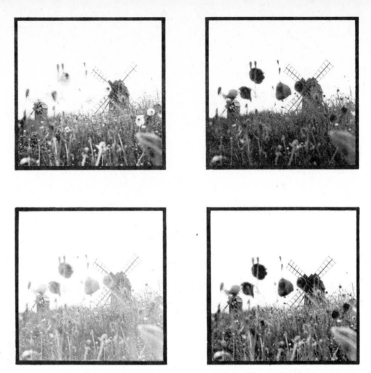

The four positives shown above have been used to produce the color image opposite. Note the relationship of the tones in these positives to the final colors. Compare these positives with the negatives on the previous page.

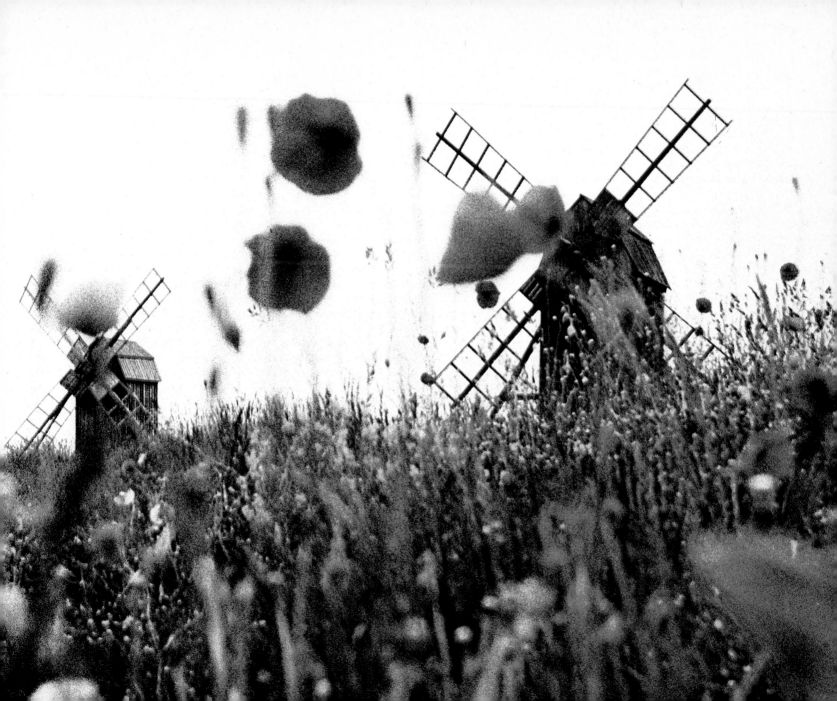

Printing through texture screens

When printing the lith positives you can obtain 'soft' results and also break up the appearance of the image by using texture screens. These are placed on top of the lith film onto which you are printing. There must be perfect contact between the two films and therefore the use of heavy glass is recommended.

Screens of various patterns and sizes can be bought from photographic stores or you can make them yourself. One attractive screen is a *reticulation* pattern which has formed many cracks – this has the appearance of dried mud. A reticulation pattern is obtained by
1, exposing a film to give a mid-tone and developing in paper developer;
2, transferring the film to a fixing bath (without hardener) as usual; 3, heat the film in water bath to 40C (104F);

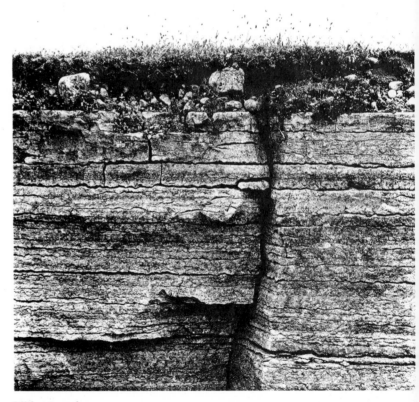

Without mask

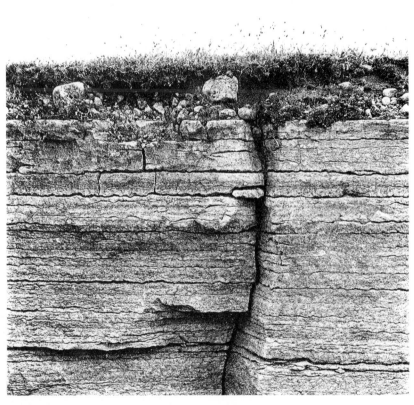

Using an unsharp positive mask

Printing the black-separation negative without a mask results in an image with too many black areas. If an unsharp 'thin' positive (shown above) is sandwiched with the lith negative then a more attractive less harsh result is obtained.

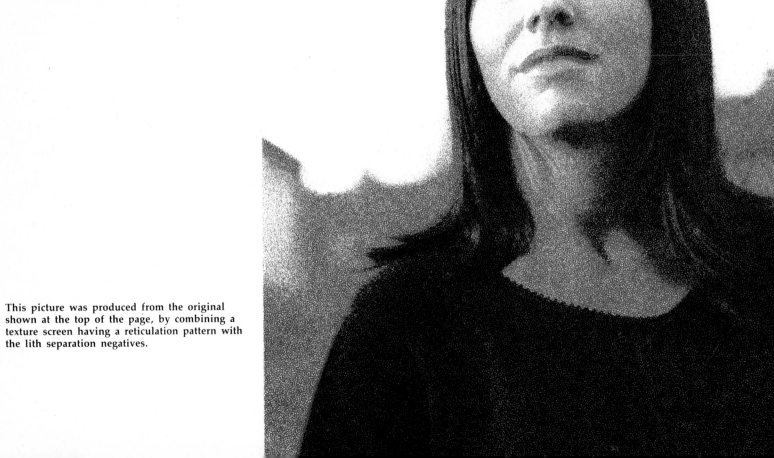

This picture was produced from the original shown at the top of the page, by combining a texture screen having a reticulation pattern with the lith separation negatives.

4, plunge straight into a cold water bath at about 10C (50F) or lower. This last 'shock' to the film causes the emulsion to 'crack'. Do not dry the film in a drying cabinet. The pattern can then be emphasized by copying onto lith film, either by contact or enlarging.

The actual reticulation pattern depends on the temperature of the hot and cold water baths, and it is worth experimenting with various films and temperatures to obtain a range of screen patterns.

Another possibility is to reticulate all or any of the intermediate lith films. This method can produce an infinite variety of final images.

After a film has been reticulated its surface is extremely sensitive and easily scratched; therefore avoid touching the film surface. Always air dry the film, do not force dry it in a drying cabinet.

The four texture screens shown on the right were produced from a film which was exposed and developed to give an even mid-tone, this film was then reticulated. The different densities were obtained by varying the exposure when this reticulated film was copied onto lith film.

Two images obtained from the same original photograph. The one on the right has been produced with the aid of a commercially available texture screen.

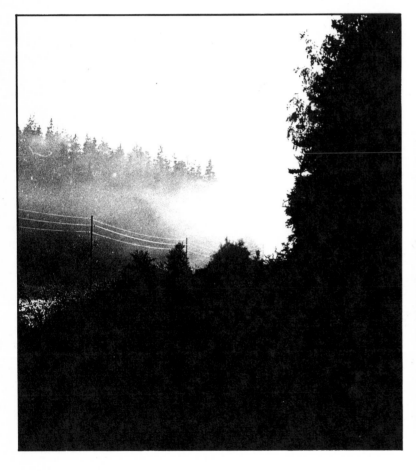

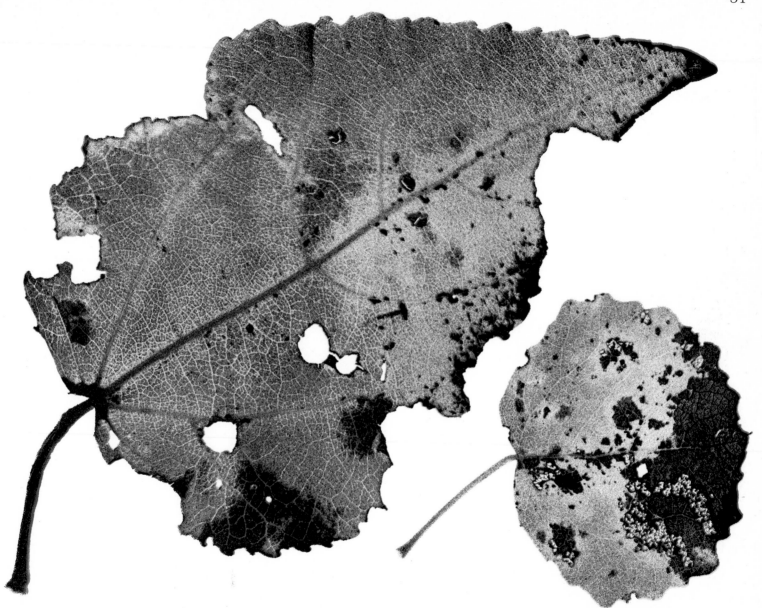

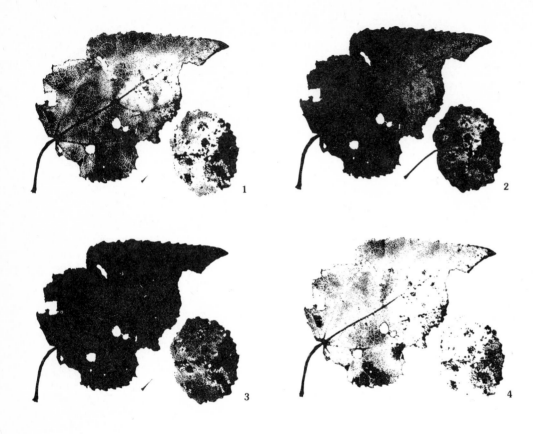

Left: these pictures show the
separation positives used for the leaf
picture:

1 = Red
2 = Green
3 = Blue
4 = no filter (black)

The leaf shown on page 51 was originally photographed four times with black and white film – once with no filter and then once each through red, green, and blue filters. In fact the very first color pictures were made in this manner, the three separation negatives being recombined later to give the color image.

The transfer to color materials

The easiest method of obtaining the final color image is to transfer each separation image onto a separate color film. This technique is very suitable when using 3M's Color Key, Agfa's Transparex and similar materials. These films are generally available in the three colors, cyan, magenta, and yellow and are normally used by printers to check the quality of color reproduction (see page 88). Some of these methods are expensive.

An alternative way is to color copy directly onto transparency film, where each lith positive is copied through a color filter.

Separation technique, step by step

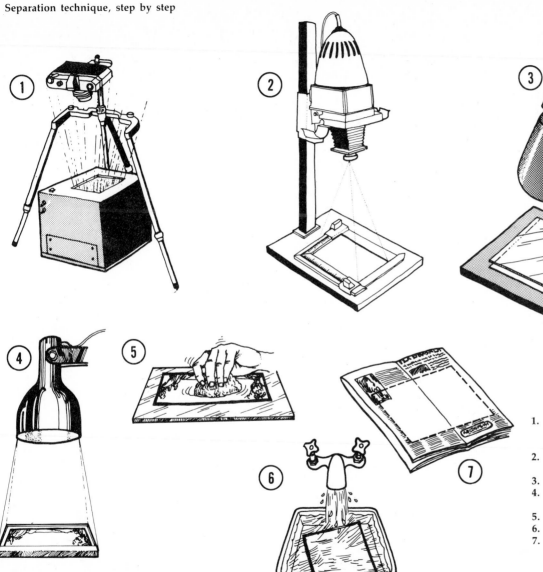

1. Copying the transparency four times using black and white film through no filter; then red, green, and blue filters.
2. Enlarging separation negatives onto lith film to give positives.
3. Copying by contact to give lith negatives.
4. Copying by contact onto color key or similar material.
5. Developing the color key film.
6. Short wash.
7. Drying the film in a 'blotter book'.

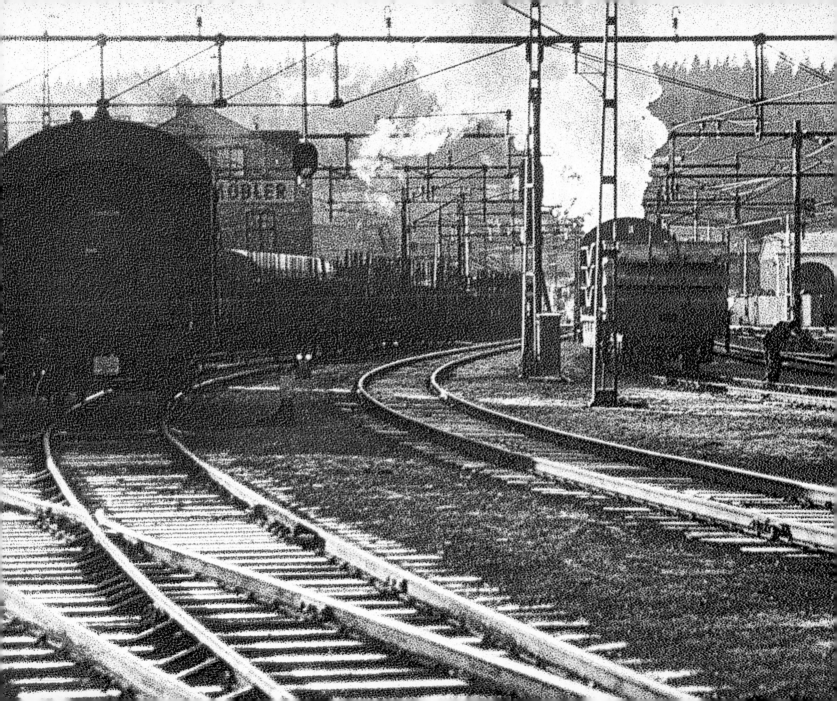

This picture is made by reticulating the lith
separation negatives.

7. Agfacontour

Agfacontour is a film primarily designed for scientific use but it can be employed in color graphics to great effect. The film converts the solid areas of negative or positive images into lines, these lines joining areas of equal tone (density). This technique is referred to as equidensitometry – the technique of extracting equal densities (equidensities) from an image.

If different exposures are made onto Agfacontour film from the same negative then different densities are extracted and quite different line patterns emerge. This method is used for analyzing X-rays and can be employed in color graphics (see pages 61–62).

How Agfacontour film is used

This film must be exposed through a yellow filter and be processed in a special developer. There is a range of yellow filters to select from, the choice being dictated by the original negative or transparency. The more dense filters produce a narrower and darker line. Generally for more contrasting originals, a less dense filter is required, and vice versa (see page 62).

The film can be exposed directly from a negative in an enlarger or by contact with an enlarged intermediate film. The latter technique is simple as exposure times are easily determined and are less variable. The enlarged intermediate film is made from the original negative or slide by copying onto lith film developed in paper developer – this gives an ideal image of soft gradation. When contact copying the intermediate it is advisable to also include a gray scale (see page 64), this being very helpful in later stages.

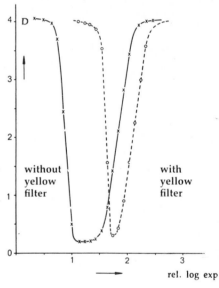

Characteristic curve for Agfacontour film

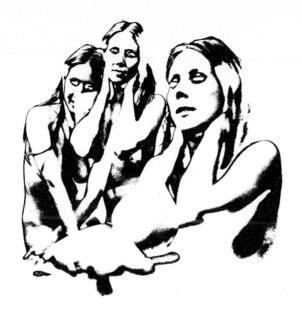

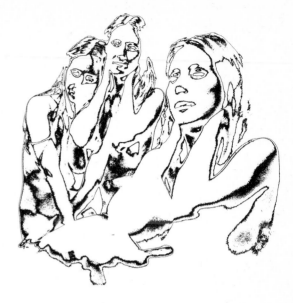

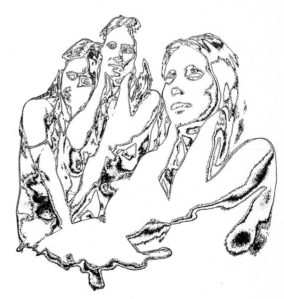

These pictures show how the image changes after multiple use of Agfacontour film. The small diagram indicates in more detail what occurs at the edges of the subject.

Developing

Agfacontour film must be developed
with care and precision, otherwise lines
may be indistinct. The process is
1, develop for exactly 2 minutes at 20C
(68F); 2, always rinse in a stop bath (2%
acetic acid); fix in a rapid fixer for at least
3 minutes. Continuous agitation should
be used throughout. It is also important
not to touch the film during processing.
The same red safelight as used for lith
films is also suitable for Agfacontour
film.

The characteristics of Agfacontour

Agfacontour produces both a negative
and a positive image on the same film.
As there is a slight displacement of these
images it is somewhat similar to a
negative and positive image being
sandwiched together.

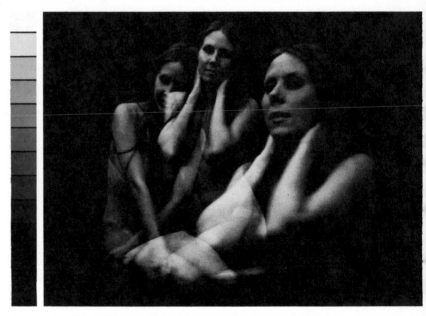

Above: the lith positive developed in paper developer, which is
used to produce the color picture on the right.

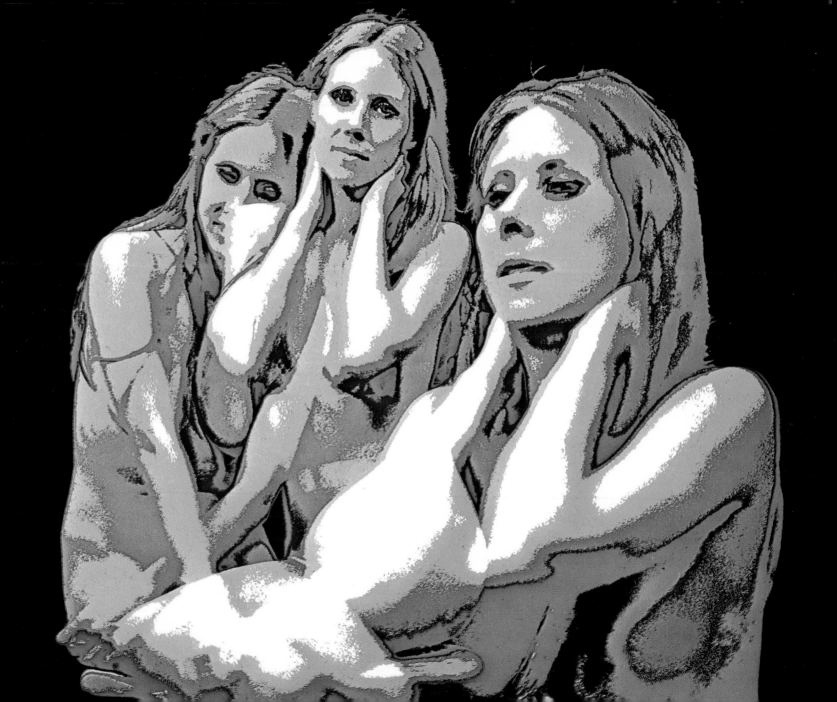

The characteristic curve on page 56 shows how Agfacontour responds when exposed without a filter and with a yellow filter. The left side of each curve represents the positive image, the right side the negative.

The use of Agfacontour in color graphics

The first step is to make five different contact exposures of your lith intermediate film onto Agfacontour film. This should produce an evenly spaced set of tone separations. It is very useful to tape a gray scale alongside your lith intermediate, this indicates more clearly how the tones have been separated. The shortest exposure should be just sufficient to separate out the lightest tone of the positive lith intermediate. If this is

y seconds then you can try 4y, 16y, 64y, 128y for the other four exposures. Examine these five Agfacontour separations and make any intermediate exposures you think necessary. It is also possible to increase the density of the yellow filter to produce more marked changes.

Coloring

From the five tone extractions you can either copy these onto lith film and use these for dyeing, or you can copy directly onto 3M's Color Key or similar materials.

Another technique is to copy each Agfacontour separation through a different color filter onto the same sheet of color transparency film. This can be done either by contact printing or by

using a camera for copying. In both cases it is essential to have some kind of registration system to ensure perfect alignment of the images. The best solution is to build a registration jig and associated registration printing frame, which can then be used for all stages of color graphics. These registration jigs and frames are available commercially, but they are very expensive.

Filters

Experiment with yellow filters of different strengths to see how they effect Agfacontour film – the results depend on the contrast of the original lith positive, the light source used for exposure, and the density of the filter.

These pictures and the two overleaf show different exposures on the lith positive (below) onto Agfacontour film. The final color image is shown on page 63.

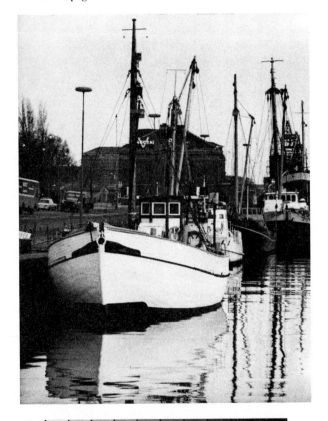

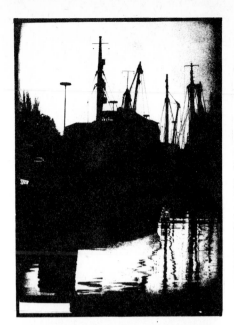

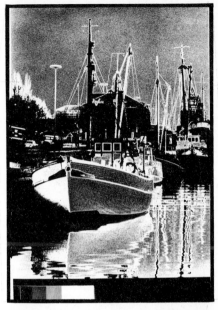

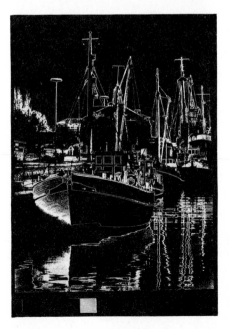

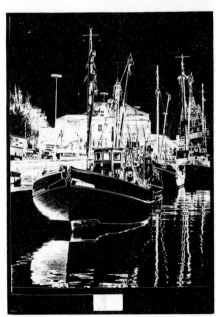

Suitable filter densities are those between 100–250 cc units. It is best to buy the yellow filter in large sheets of 50 cc and 100 cc density, these can then be cut and added together to give a range of strengths.

Gray scale

This can easily be made by exposing a large sheet line film to give an even light gray tone, this tone being the first step of the gray scale. The complete scale is made by overlapping strips of this processed film until the most dense step has 9 layers of film. This gray scale, now consisting of 10 steps (the first having no density), is now copied onto a continuous tone film such as Kodak

Gravure Positive (for more details see page 64).

Retouching

Photo-opaque can be used to hide small blemishes on the film or to 'block out' large areas of unwanted image. The technique is the same as for retouching lith films (see page 110).

Original material

Almost any kind of film including color film, can be printed onto Agfacontour, so do experiment as much as possible. Although most subjects can be copied onto this film, those having strong lines and simple shapes (eg flowers, buildings) are usually more successful.

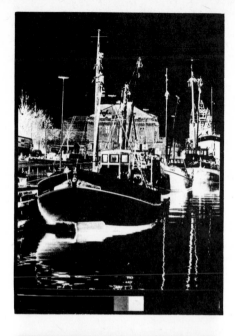

The final color picture
obtained from
Agfacontour separation
films.

As Agfacontour film works by separating the tones of the original subject it is virtually impossible to obtain natural colors, although this can be possible when large different parts of the subject have very marked differences in tone and color. This book has only given an indication of the possibilities of this Agfacontour technique and you should experiment with other methods such as solarization and multiple exposure.

Above: the diagram shows one commercially available registration system for aligning films used to produce color graphics. The guillotine is used to ensure that all films are of the same size and 'squareness', and the supports on the light-box ensure registration. A flash box (see page 40) can be employed for this technique.

The diagram (right) shows how a gray scale can be constructed from a processed sheet of film having a light tone.

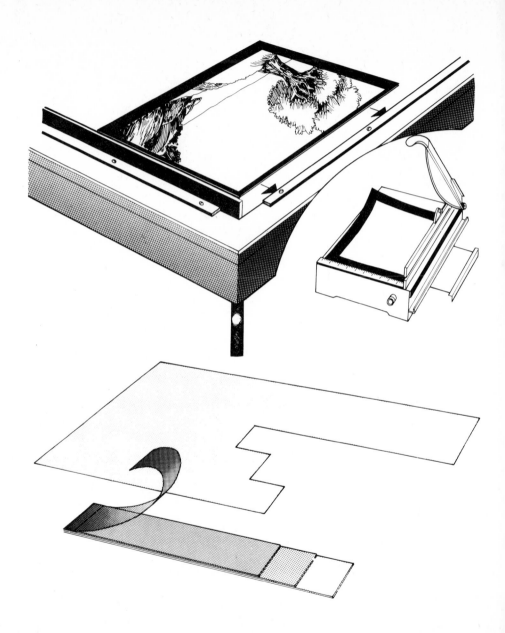

8. How to dye films

Bleaching and etching

This method was described briefly on page 11. Where the image is bleached (ie. where there is silver); there is also a relief image formed as the gelatin is etched away. This means that the etch-bleach process takes place on the exposed and developed areas of the image. After the image is fixed there is only a relief image in gelatin.

The first step in the process is to contact print the separation positives onto high contrast film to obtain separation negatives. The exposure should be just sufficient to give a maximum black after normal development. After development the films are rinsed in a stop bath, then washed in running water for a short time, then into the etch-bleach, and given another short wash in *cold* water. The film is then carefully air dried.

The best films to use for the etch-bleach process are those with thick emulsions as these finally give the most saturated colors. Suitable films include those used by the graphic arts industry such as Kodak Process film. They can be developed in paper developer where the temperature should be strictly controlled to 18 – 20C (64 – 68F).

The etching bath consists of 9 parts of solution A to one part of solution B; once mixed it does not keep and a new bath should be made for each session.

SOLUTION A
10 g copper chloride.
50 ml glacial acetic acid.
Add water to make one litre.

SOLUTION B
20% hydrogen peroxide.

The film is *not* agitated in the etching bath and should be left for one minute. It is then carefully removed and washed under running cold water, preferably with a hose (eg. hand shower attachment).

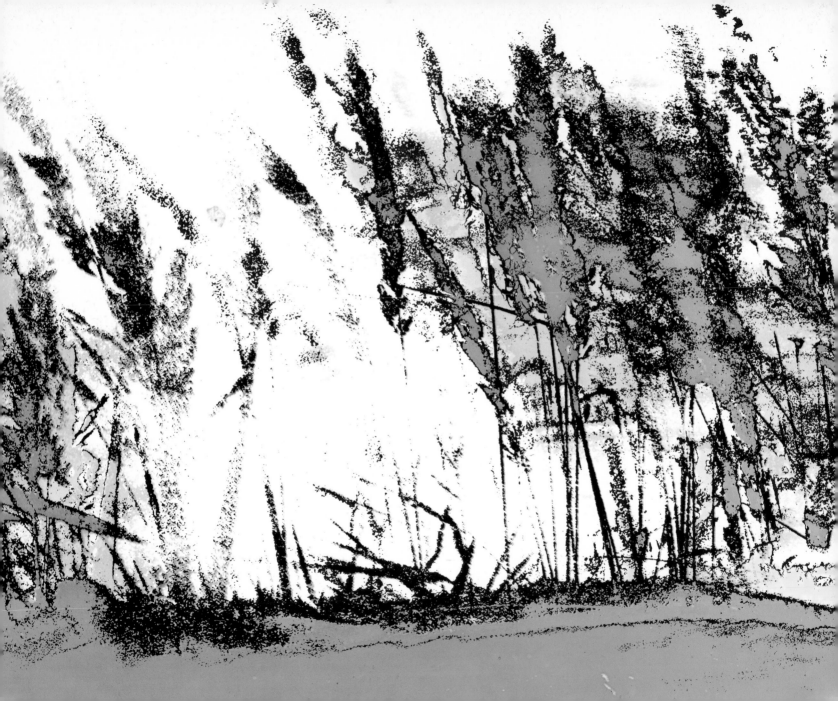

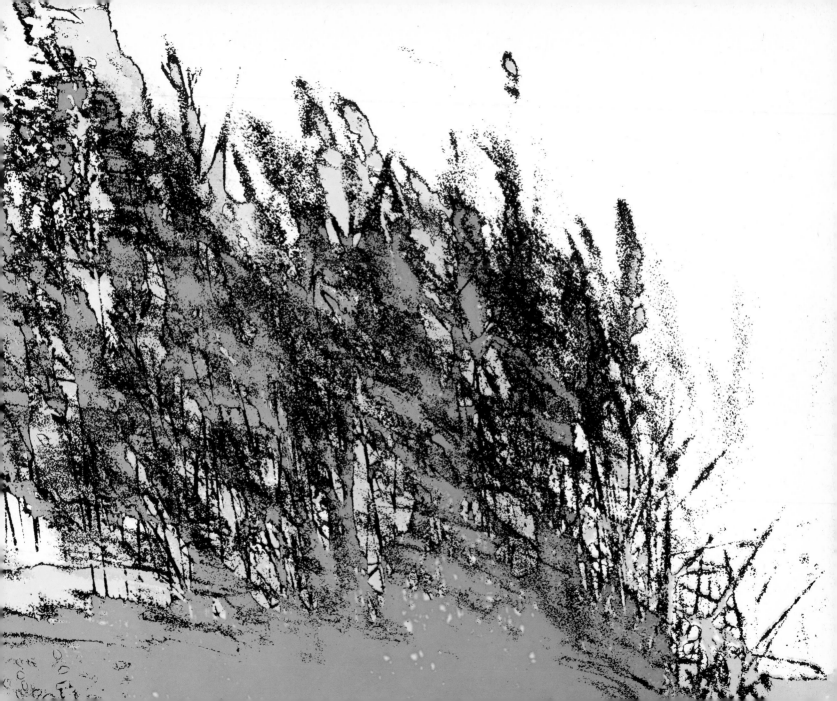

These four films were used to produce the color image on the preceding pages. The original scene was photographed many times using different exposure times to give varying amounts of 'blur'. From this series of exposures these four were selected for use.

After the film has been completely etch-bleached all the image should have been removed – if it has not then you can repeat the etching step. If this still does not work then your exposure was too short. A fine gray veil may remain after washing but this can be carefully removed with a chamois leather.

An acid hardening fixer should be used, as this toughens the gelatin for the remaining steps of the process. You can also put the film into a special hardening bath.

Hardening bath

12 ml formalin.
5g anhydrous sodium carbonate.

Add distilled water to make one litre. Immerse the film for two minutes in this hardening bath immediately after the fixer, and follow this with a short wash. The film is now very susceptible to scratching and should be handled with care. Before placing in a drying cabinet wipe the film carefully to remove excess water, otherwise parts of the emulsion will 'run off' the film base.

To avoid dye absorbing into the back of the film, it is necessary to spray a thin layer of varnish on this side of the film. Polyurethane varnishes are ideal for this purpose. Check the position of the film code notch to ensure you are spraying the back of the film. It is essential to prevent varnish from getting onto the emulsion side – this is best achieved by taping the film (emulsion down) onto a flat board. Tape the edges of the film to ensure that no varnish can creep underneath it. You are now ready to dye the film (see page 77).

The picture above was derived from Agfacontour separations.

A 'photogram' negative, made by placing the plant directly onto the film, was used for the picture on the left.

The leaf picture (right) was made by initially placing the leaf in contact with the film. This first lith film was then contact printed onto another sheet of lith film, which was 'solarized' during development.

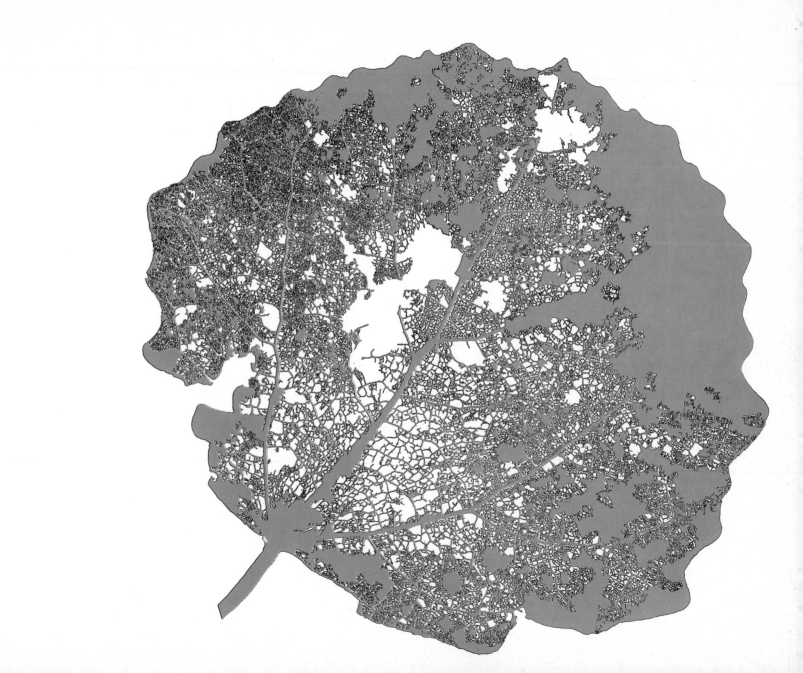

The color wheel

This is a circular scale where one color leads into another, finally returning to the starting color. The primary colors are red, blue, and green; with intermediate colors of orange, violet, brown, blue-green (cyan), and yellow-green.

Color wedges

These are similar to a gray scale but instead show various densities of one color. The color of a particular wedge can be saturated (very pure color), medium saturated, or unsaturated (pastel color which is close to a gray).

Color mixtures

There are a number of ways to mix colors. For example, in color graphics a mixture of dyes can be dissolved in one bath and this can be used to dye a film(s), or alternative separate films can be dyed with different transparent dyes and these can be overlaid to give the final colors. This last method is known as *subtractive color mixing* since the final color is derived from white light (ie, a mixture of all colors) – each overlapping dye *subtracts* certain colors from the white light and the remaining light is the resultant color.

The method used on page 60, where several exposures through different color filters are made onto the one sheet of color transparency film, is known as *additive color mixing*. The final colors are obtained by adding several colors, each color coming from a separate exposure through a color filter.

Opposite: this picture was made from a combination of tone separation and solarization. The original negative was a deliberate double exposure. A slight displacement of the colors have been achieved by moving the printing material between each separate exposure.

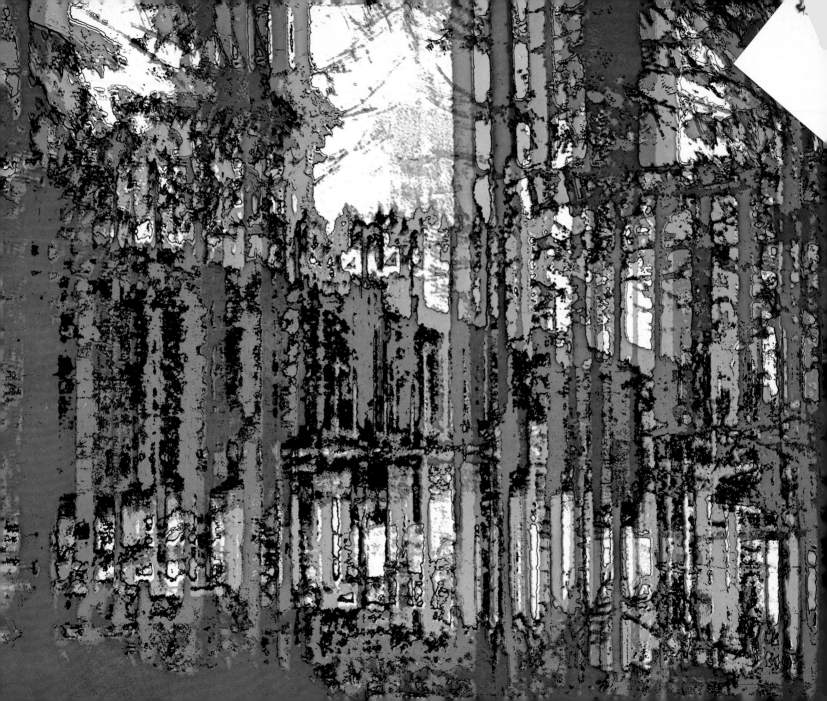

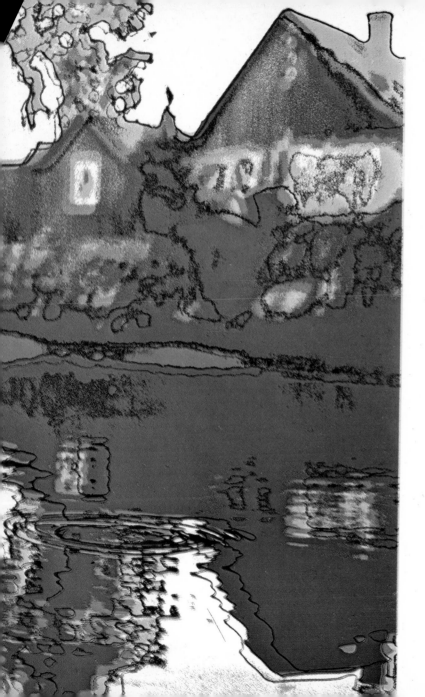

Warm and cool colors

Most colors can be described as either warm or cool. For example; red, yellow, and orange are considered warm colors whereas blue and green are cool colors. Some colors can be difficult to classify and may appear to contradict the broad classification above eg. olive green is a very warm green color when compared to ice-blue.

You can create a very cold and strong color effect by adding a cool color to a series of warm colors. The picture on page 106 is an example of this.

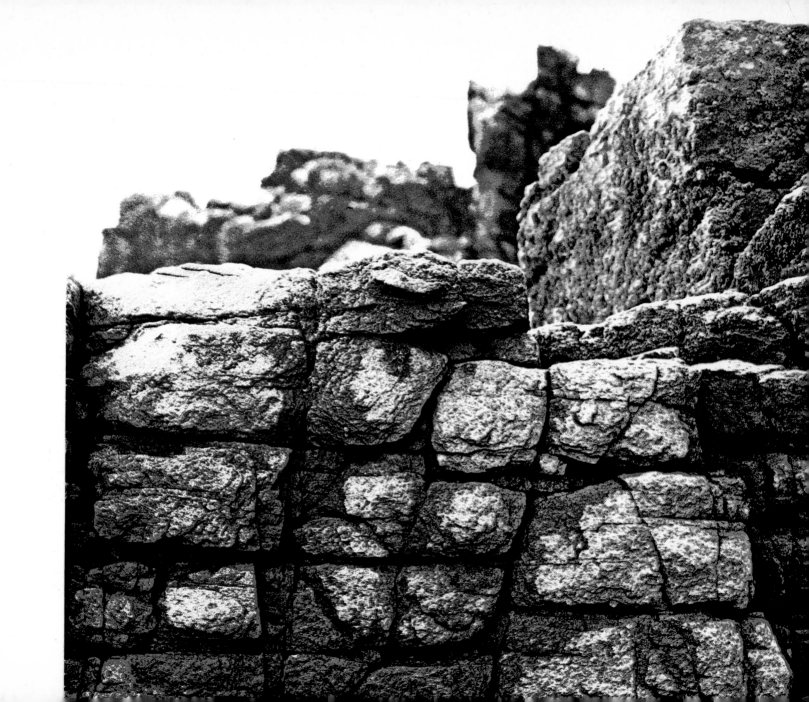

Harmonizing colors

For successful color graphics it is essential to select colors which 'harmonize' or are in 'sympathy' with one another. This choice is obviously a personal one but there are some general guide lines which can help this selection. Sometimes you can select colors which deliberately do not harmonize so that you can make a strong visual impact. The beginner should try to keep his choice of possible colors to around twenty, and in this way he avoids awkward color clashes. Most final colors in color graphics tend to be pastel in nature and are considered fairly *unsaturated* – saturated colors are very pure colors (eg, the colors of the spectrum). When you are using subtractive mixing of colors, as when one dyed film is laid on top of others, it is essential to experiment first to see how various colors are produced. Experiment with say six saturated colors, six colors of medium saturation and some gray tones – once this 'set' is mastered you can add other colors to it.

The type of subject you are photographing, obviously influences the range of colors you are likely to be using – blue and greens usually predominate for landscapes and reds and yellows for portraits.

Color composition

Good color composition really means balancing the colors within a scene so that they are evenly weighted. A small strong bright color in one corner may have to be balanced by a larger more subdued color in the opposite corner. Often a warm color can be balanced with a cooler color – a red flower makes a pleasing color composition when surrounded by green foliage.

Many successful color compositions do in fact only have a small proportion of strong color and may appear almost monochromatic. Too many colors 'splashed' around the scene tend to look crude and gaudy, so try to keep your color compositions fairly simple.

Colors also help to give photographs a three dimensional appearance, with warm colors tending to 'advance' and cool colors to 'recede'. Therefore the choice of color has a great effect on what appears to fill the foreground of the image.

Some color graphic examples

The simplest use of color shown in this book is that of two-color, where the background is predominantly one color and the foreground the other. The examples of the cog-wheels on page 23 show how a subject which is spread across the entire picture produce a simple balance.

The picture on page 81 shows how one color, but of three different degrees of saturation, can be effectively used to give a tonal color composition. You can try using the same color with all film separations and allow the various image overlaps to create different densities.

The house by the river (page 74) is a four color picture where a good color balance has been achieved by spreading the colors around the picture.

Note the small patches of blue on the water, which help to produce an image of quiet calm.

On page 75 is an attempt to reproduce a naturally colored landscape. As stones in nature are a variety of colors, it is possible to color them, within limits, as you like. The depth of stone is emphasized by the blue highlights on the stones in the background.

The final color step

So far, only methods of obtaining the separation films have been described. To obtain the final color graphic these films must be colored or converted to color. The methods of doing this include dyeing, 3M's Color Key, offset printing, silkscreen, Kodak's Dye Transfer, and color printing (onto film or paper).

Dyeing technique

This is the most economical method of coloring the image. Most of the dyes used are those designed for dyeing textiles and must be of the 'acid' type.

Alkaline dyes are not recommended for dyeing gelatin and neutral dyes may produce uneven coloring. Dyes must be transparent so that they can be used for films which will be overlaid. These dyes can be bought in most hardware stores, and those suitable for dyeing cotton are the best. For example, Dylon dye (sold in small aluminium cans) is a powder which is dissolved in 300ml of hot water, and then shaken vigorously and allowed to cool. This cooled solution can then be used for many dyeing sessions before it becomes exhausted.

Dye solutions must be stored in dark bottles (glass or plastic) as some are faded by light.

If you are likely to use larger quantities of dyes buy them in one kilogram industrial sizes. You could buy three or four primary colors and then mix a range of tones from these.

For the beginner, it is difficult to mix dyes and obtain any consistency. Therefore you should follow a standard color mixing system such as *Pantone*. This system is based on mixing eight different primary colors, black and white. By mixing various quantities of these ten dyes you can obtain 487 different color tones – these being shown on a sample card. The *Pantone Matching System* is used by many industries including those concerned with textiles and printing.

It is important when initially mixing dye solutions to weigh out quantities exactly, since a small change in dye concentration has a large effect on final color. Once the initial dye solutions are made, the mixing of them to produce your color system is relatively simple.

Pictures on the previous pages:
Left: a tone separation which has been solarized.
Right: a tone separation combined with lithographic printing.

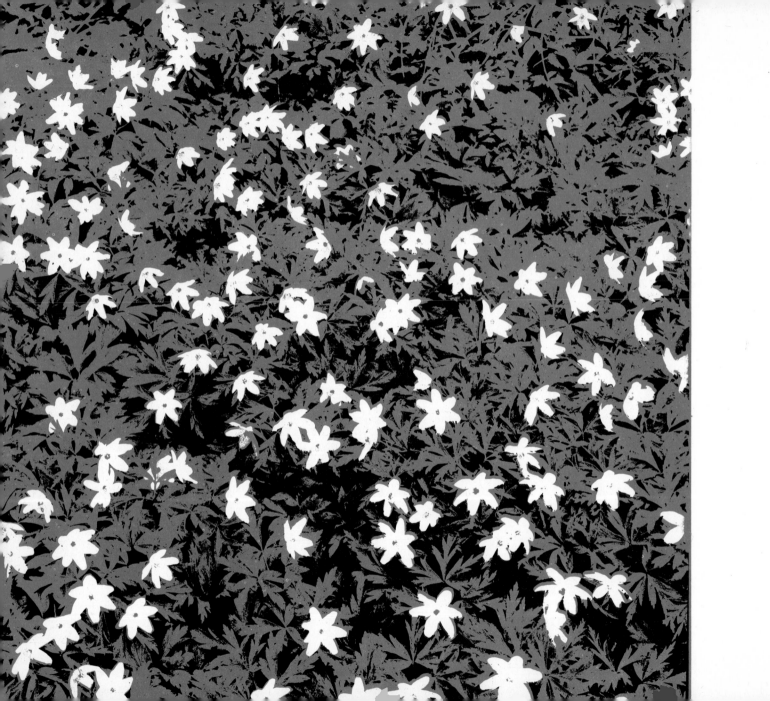

To make your primary colors you should proceed as follows:

1. Dissolve the pigment in boiling water. As the dyes readily stain most materials it is best to work either on a plastic covered work bench or outside.
2. Cool the dye solution and filter through a paper filter – coffee filters are ideal.
3. Test the strength of color with fixed-out photographic paper which has been well washed and dried. Paper absorbs more dye than film and therefore gives deeper colors than dyed film.

It is advisable to start with smaller quantities of dye than suggested and increase the amount until you are happy with your test results. You can always add more dye solid but it is awkward to reduce dye strength by dilution of dye solutions. The most successful colors are usually those which are shown as darker on the sample card.

The dyeing process

The film should be dyed in a large dish. Always shake the solution before pouring into the dish. The film should be continuously agitated while in the dye bath, the actual time of dyeing depending on the color and the density required. Sometimes it is more convenient to wipe off the film, check its saturation, then reimmerse in the dye solution if necessary. If the color is too intense then it is usually possible to reduce the density by dipping the film into a water bath.

The author has found when using strongly saturated colors that a quick rinse in water immediately following dyeing helps to give even coloring and produces a more brilliant color. Remove all excess water immediately after this rinse with a film wiper. After drying the film is mounted (see page 93).

Color key printing

The 3M's Color Key system is used by color lithographic printers to quickly and cheaply check the quality of their color work. Each of the printer's color separations is individually printed onto the appropriately colored Color Key film eg. red separation film onto cyan film and so on. This same 3M product can be used to produce dyed film images from color graphic separations. Color Key is a dimensionally stable film (polyester base) which is available in more than 40 colors and color coded to fit the American Pantone system.

These pictures were commissioned by Swedish Radio for covers of booklets designed for school broadcasting. All pictures use two colors.
Far left: a leaf which has been copied at three different sizes. Next to this is a photograph of a book with its pages being 'flipped' during a long exposure time. Right: this design was derived from several solarized images.

Color Key film is very thin but still remains very flat throughout all the operations. Each film emulsion contains its own specific color and a chemical which causes hardening of the gelatin when it is exposed to ultra-violet light. It can be handled in normal room lighting and can be exposed with a sunlamp, although a UV light is better if one is available. The film is processed by a special developer which removes all the unexposed parts (unhardened by UV exposure). This means that you expose a negative onto the Color Key film.

The final Color Key film has a single transparent color and is clear in non-image areas. Several of these images are then mounted on top of each other to give the final color graphic transparency. There is also available a positive-working Color Key film which needs a positive image to generate a positive image. It also uses a special developer.

Working technique for Color Key film

Negatives of high contrast (eg, lith negatives) are the most suitable original for printing onto Color Key film. Place the Color Key film emulsion *down* (the film has the standard coding notch) with the lith negative (emulsion down) on top of this. Exposure is then made through a sheet of glass on top of the negative. It is also advisable to place a sheet of black paper under the Color Key film to prevent back reflection.

The exposure is critical. Try a test exposure of 3½ minutes with a 300 watt sunlamp at a distance of 50cm (1½ ft).

The film is then placed emulsion side up on a glass plate and processed by pouring the Color Key 'negative' developer into the middle of the film; the solution is then spread by a wad of cotton wool used in sweeping movements. Non-hardened parts should be removed fairly easily. Be careful not to scratch the film.

If the unexposed parts do not become clear then repeat the development step, and if this is not successful then the film has been overexposed. Take another test strip of film and reduce the exposure. The disappearance of the entire emulsion on developing indicates that the exposure is too short.

Finally, the film is washed in *cold* water for two minutes and dried between absorbent paper (eg photo blotter book).

Color Key process – step by step.

1. Contact printing a lith negative onto Color Key film.
2. Developing on a glass plate.
3. Short wash.
4. Drying Color Key film between blotting papers.

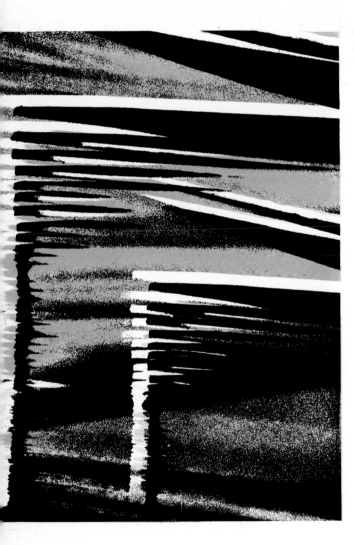

This two-color picture is from the same assignment described on pages 86–87. The image is a close-up of a book.

The pattern surrounding the IBM ball is a
solarized close-up profile of the letters on the ball.

Method for dyeing films and producing a composite color transparency.

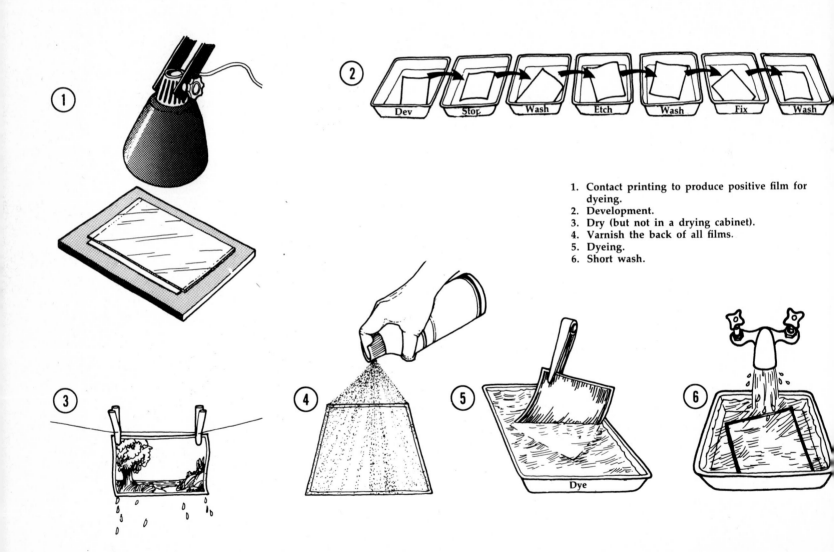

Dev · Stop · Wash · Etch · Wash · Fix · Wash

Dye

1. Contact printing to produce positive film for dyeing.
2. Development.
3. Dry (but not in a drying cabinet).
4. Varnish the back of all films.
5. Dyeing.
6. Short wash.

Mounting of color films

Once the films are dry you can mount them to give the final composite color graphic. Start by taping a white sheet of paper down on your easel and then fix on top of this the most contrasting image (this is usually the black image). If you have a solarized film then it may be best to start with this image, as the lines help define the edges of the other images. When lining up the images, you should look at the center of the picture using only one eye.

The registration of the various films must be very exact and they should be taped down with non-stretch tape available from graphic arts stores.

The above method of mounting gives a 'color print' against a white background, but the composites can be viewed as transparencies when placed on a light box with the white paper removed. Color Key films are designed to be viewed against a white background as 'color prints'.

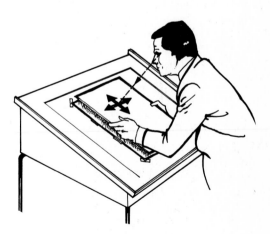

For aligning the various color films you should view them from a reasonable distance and look at the center of the picture using only one eye. Once positioned each image should be fixed with non-stretch tape. The picture should be 'finished' by placing a black frame around it.

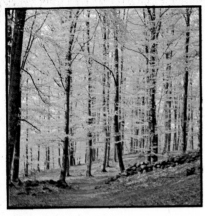

Above: the transparency shown above has been used to produce the graphical image of the trees (right).

Far right: the image of the house has been obtained from a black-and-white negative. At the same time a color transparency of the scene was taken for reference only: see below.

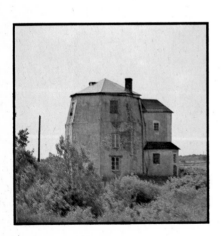

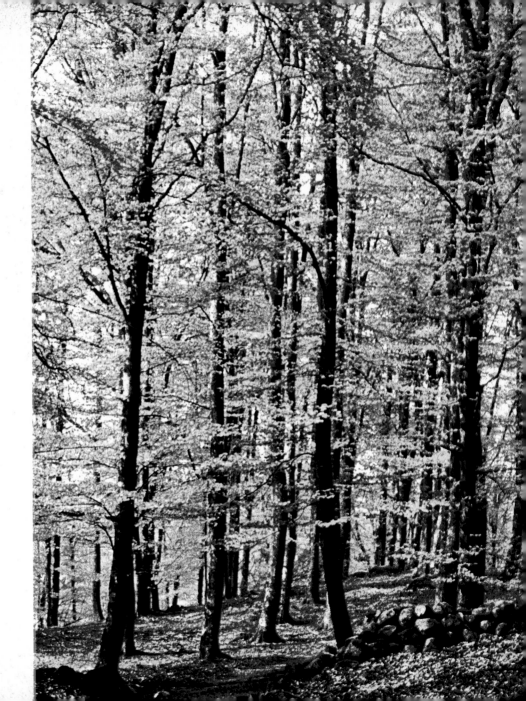

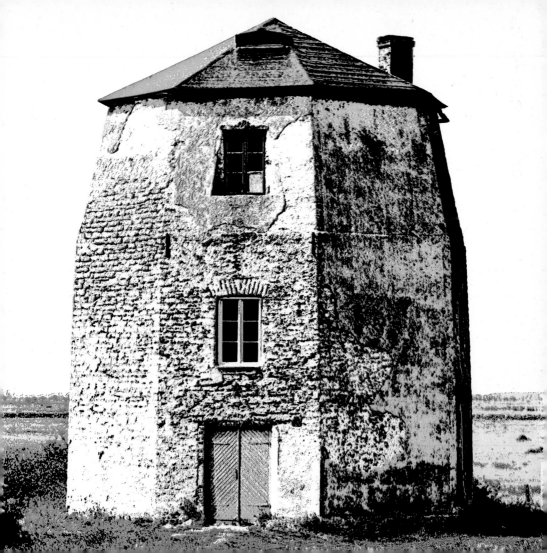

Right: this color picture was derived from an original black-and-white negative taken by Hasse Persson (from *New York – Town of Contrasts* **published by Spektra).**

Kodak Dye Transfer process

This technique is primarily used to produce very high quality color prints from color transparencies, and is most suitable where a relatively large number of prints are required. The Dye Transfer process can also be used very successfully in color graphics, but again is really only suitable (because of expense) for producing at least ten copies of the same picture.

The basic technique is similar to the dyeing process described earlier, except that each color dye is transferred from a special film ('matrix') onto a receiver paper or film. The final Dye Transfer print consists of successive color images (usually three) which have been absorbed (imbibed) in register by the receiving sheet – most have a cyan image, a magenta image, and on top a yellow image. These Dye Transfer prints, when carefully made, are of high color saturation and very resistant to fading by light. The process basically consists of:
1, original camera film is used to produce color separation films; 2, each color separation film is used to make a separate Dye Transfer Matrix – these are processed in a special developer which hardens the gelatin in the exposed areas, unhardened gelatin is removed by a hot water wash; 3, the matrices, with their gelatin relief images, are soaked in the appropriate dye bath and transferred one at a time to be absorbed by the receiving sheet. Obviously registration has to be very accurate. The amount of dye transferred is in proportion to the thickness of the gelatin at any one part of the matrix image.

This has only been a very brief description of a relatively complex process and more details can be obtained from an excellent Kodak booklet on Dye Transfer.

Color printing

The color separation negatives can be printed onto color paper to give a conventional color print. Each separation negative is printed in register through the chosen color filter in sequence to 'build-up' the final color picture. To achieve accurate registration a special enlarger negative carrier is required.

The author feels that conventional color printing does not offer the best method for color graphics – results are often lacking in 'sparkle' and do not have the flexibility of other techniques.

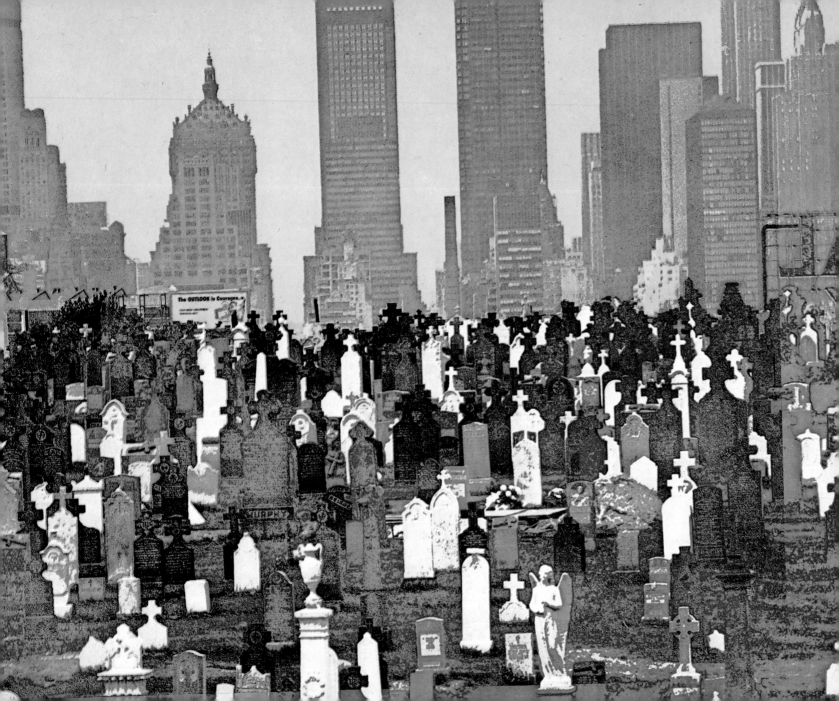

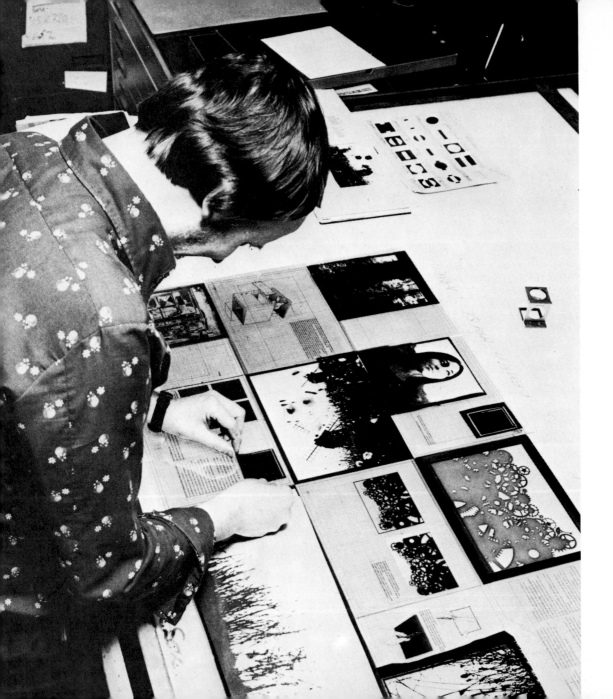

Two pictures of the printers working on the color separation films for this book.

Printing

The very best methods of printing color graphics are offset lithography and silkscreen printing. Both these techniques are capable of very high quality but demand longer print runs (silkscreeen about 50, lith in thousands).

Silkscreen printing is suitable for the amateur and most of the equipment can be handmade. A tissue is stretched across a frame and the ink is drawn across the frame with a wiper blade – the ink is forced through the open parts of the screen to produce the image on the paper beneath. A different frame is used for each color of ink. These frames are kept in register by using microscopic hinges.

Each sheet of silkscreen material is exposed in contact with a lith positive or negative by UV light, and developed to give a screen which is porous to ink in certain areas (depending on whether the screen material is negative or positive working). It is best to have the receiving sheet of paper held to the printing table by a vacuum pump, a domestic vacuum cleaner can be adapted to this task. Once you have made the initial investment in silkscreen equipment, this method offers the most attractive system for the keen color graphic printmaker.

For the ambitious printmaker, lithography offers the most versatile but the most expensive system. Lithographic plates can be made directly from your color separation films, whether they are positive or negative. The color separation films are used in place of the normal half-tone films employed in most lithographic printing. When color graphic images are to be printed together with conventional four-color half-tone images,

it is better to produce a color graphic transparency (by dyeing etc.) and have this reproduced in the same manner as color prints or transparencies (ie, four color separation and half-tone reproduction).

The color chosen for lithographic printing can be specified by the PMS system, mentioned on page 78. When you require large prints of poster size it is best to get the printers to produce the final separation films, as a conventional enlarger does not give accurate enough registration in the corners of the image.

Applications of color graphics

Color graphics are employed for many purposes including use as posters, book covers, packet designs, advertising, and patterns for various fabrics and materials.

Some examples of registration marks. You can either buy commercial marks (left) or you can draw a simple pattern of squares and photographically reduce them in size.

This picture is derived from a technical study of a window and its surrounding structure.

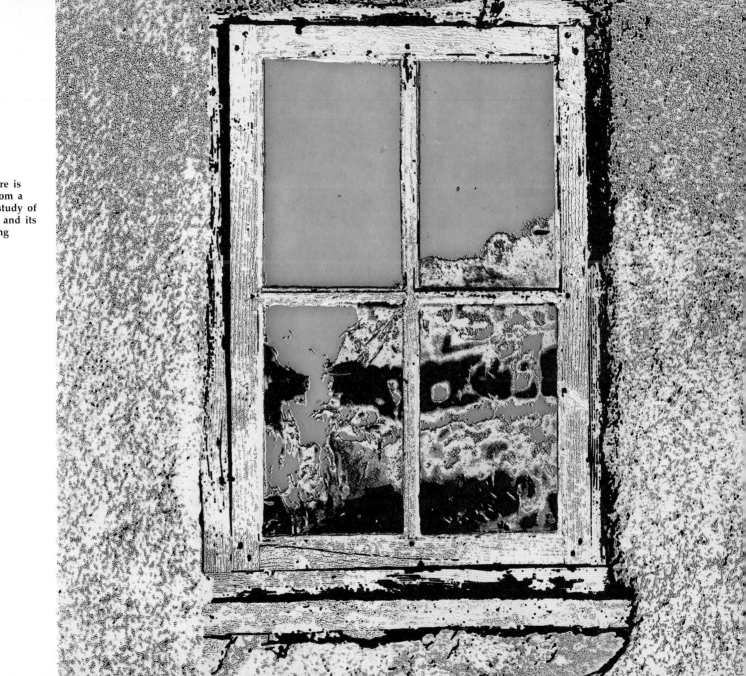

As book covers, color graphics have several distinct advantages over conventional photography or artwork. They are cheaper to produce because the expensive color separations required for four-color printing have already been produced. The printer simply makes his printing plates from the color separation positives (or negatives) supplied – no half-tone screening is needed. Also the technique of color graphics can turn an otherwise uninteresting but essential subject into a very appealing design. The total book design (image and typography) can be supplied in a finished form by the photographer.

As yet, the world of advertising has not made extensive use of color graphics but there are many excellent opportunities for work in this area. Possibilities include images for display posters, newspaper and magazine advertising, sales brochures – these openings are likely to become more frequent as more printing is produced by lithography.

The textile industry is always looking for new design ideas and color graphics are very suitable for the long continuous repeat-patterns they need. Although conventional half-tone photographs have been used successfully on fabrics, they do not have the abstract 'mystery' of color graphics. An easily assimilated image such as a conventional photograph soon becomes boring when you have to look at it everyday in the same room. A color graphic image gives the viewer more to 'work on' and never becomes boring when printed on a fabric. Many of the pictures in this book have been used for patterns eg. the leaf on page 71 was used as a plastic laminated table-top.

If you are arranging a series of the same or similar images to produce a pattern, then you should use transparent registration marks to ensure perfect alignment.

Retouching

The intermediate films used to make the final color graphic often need quite extensive retouching before the next step can be undertaken. This retouching takes two main forms: 1, removal of all blemishes (dust, spots, etc.), many of which are inevitable when contact printing; 2, major retouching which removes complete parts of a subject, this being used to improve the composition. Retouching of blemishes is best kept to a minimum by ensuring all equipment is

kept very clean and covered when not in use. A can of compressed air ('air duster') or a blow brush is an extremely useful accessory. Blemishes should be retouched with a small (size 0 or 1) sable brush which is used to apply the photo-opaque in as dry a state as possible. Where grainy areas have to be retouched, then apply the opaque by 'spotting'; use a dabbing motion.

To block out complete areas of a subject use special red tape and photo-opaque. Sometimes it is necessary to tape another film to the one you are retouching as a reference to the visual intent of the subject. The picture on page 95 has employed this technique to remove unnecessary detail from around the building.

Good brushes are expensive and should be thoroughly washed with lukewarm water immediately after use. Their tips should also be 'repointed' so that they dry to a fine point.

Retouching is much easier when you work with larger film sizes. Try to use film of at least 10 × 13cm (4 × 5 in) in size.

Summary table

	Suitable subject	Original camera exposure
Two-color picture	Any subject	At least three 'bracketed' negatives from under- to over-exposure
Tone separation	Subject with an evenly spaced soft tone scale eg. landscape	At least six negatives preferably from —1 (1 stop under) to +1½ (1½ stop over) in ½ stop intervals, and one negative at +3
Multi-color using the masking technique	Contrasty subjects with very strong design, which should also have large areas of one tone	Expose at least twelve frames ranging from over to under exposure. If the subject is moving then overexpose by 2 stops. Try other techniques such as moving the camera, double exposure
Combination pictures	The main subject should have areas in the image which are suitable for 'dropping in' the other image(s)	Contrasty negatives are needed – underexpose and overdevelop

Number of colors	Graphical treatment
Two	Lith negative and positive for each color. Alternatively two positives of different densities (as a rule the lighter positive becomes the black and the dense positive the color in the final image)
At least three but not more than five	Lith or solarization separation. Possibly a solarized outline for each color area
Normally four colors	Ordinary lith printing possibly combined with solarization. Solarized outlines give the best color effects. Masked printing is also a useful technique
Normally more than four colors, but this depends on the subject. The simplest variation is one color for the main subject, one color for the background, and black used partially over the entire picture	Lith printing and use of masks. Possibly also multi-combination masking

Index

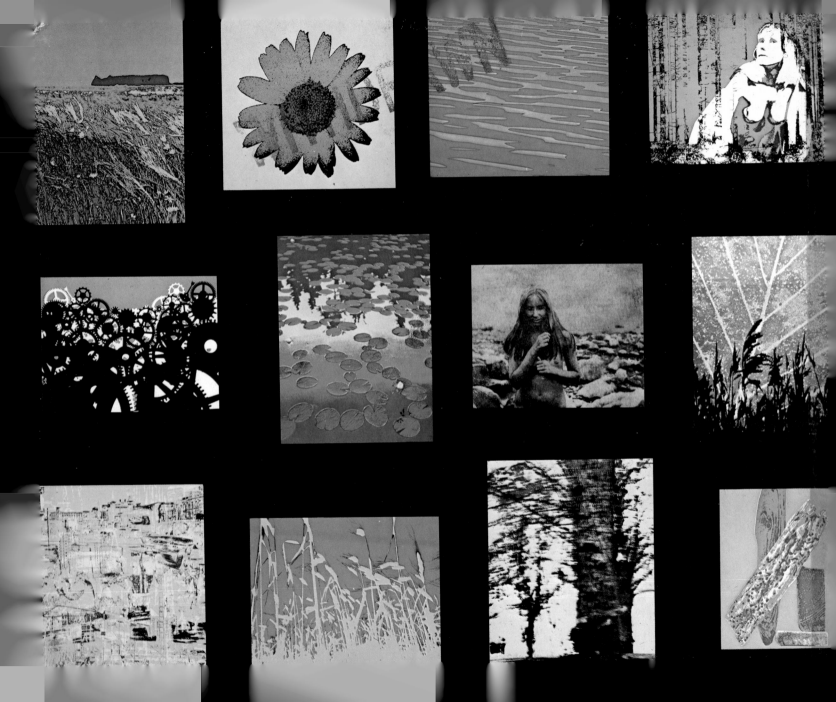